Tempests and Romantic Visionaries: Images of Storms in European and American Art

Tempests

Tempests and Romantic Visionaries: *Images of Storms in European and American Art*

OKLAHOMA CITY MUSEUM OF ART

Publication Notes

This catalogue has been published in conjunction with the April 21 – August 13, 2006 exhibition *Tempests and Romantic Visionaries: Images of Storms in European and American Art*, which was organized by the Oklahoma City Museum of Art.

Executive Director: Carolyn Hill
Curator and Editor: Hardy S. George
Assistant to the Curator: Lindsay Hightower
Copy Editor: Jeffery J. Pavelka
Designer: Eric H. Anderson

© 2006 Oklahoma City Museum of Art
All rights reserved. Published 2006
Printed in the Unites States of America

Oklahoma City Museum of Art
Donald W. Reynolds Visual Arts Center
415 Couch Drive, Oklahoma City, Oklahoma 73102
Telephone: 405-236-3100
www.okcmoa.com

Library of Congress Control Number: 2005938898

ISBN: 0-911919-04-X

Cover Image
Claude-Joseph Vernet (French, 1714-1789)
The Storm, 1787
Oil on canvas, 45 x 59⅝ in.
Wadsworth Atheneum Museum of Art, Hartford, CT
The Ella Gallup Sumner and Mary Catlin Sumner
Collection Fund

Editors Note
Throughout this publication, names of ships are given in italics. When included in italicized titles, ship names are alternatively set in Roman type.

Photography
Jim Frank (p. 68)
Denis Farley (p. 45)
Brian Merrett (p. 70)
Christin Guest (p. 6)
Metropolitan Museum of Art (pp. 10, 54, 102, 106, 107, 109)
Robert E. Mates Studio, N.J. (p. 119)
Stephen Petegorsky (p. 13)
Jim Meeks (pp. 20, 121)

Tempests and Romantic Visionaries:
Images of Storms in European and American Art

OKLAHOMA CITY MUSEUM OF ART

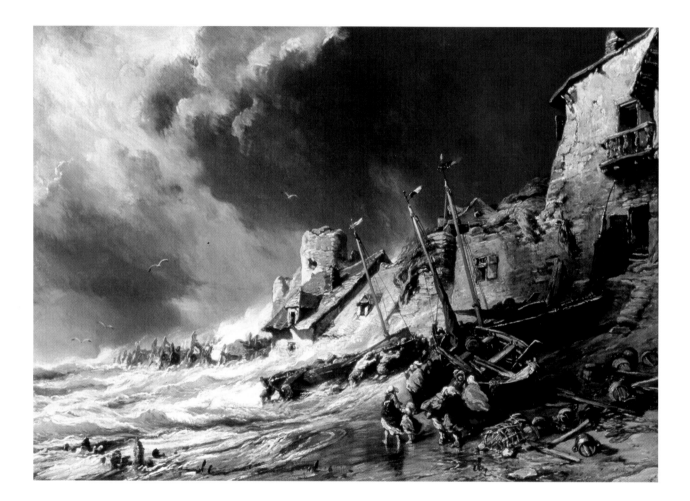

Eugène Isabey (French, 1803-1886)
Brittany Coast Scene, 1860
Oil on canvas, 18 ³⁄₁₆ x 26 in.
The Montreal Museum of Fine Arts, Gift of David A. Wanklyn

Introduction and Acknowledgments

Carolyn Hill

The awesomeness of power, whether that of the tempest or the sublime, has inspired artistic expressions in all disciplines for centuries, perhaps none more dramatic than those based on the storm motif, a favored theme of artists of the Romantic period. This type of subject was influenced not only by the visual drama cast by stage and set designs of the day, but also by the great pictorial ancestry of seventeenth-century Dutch landscapes and seascapes. The Romantics were drawn to the diametrical opposites of turbulence and calm which set the stage for highly charged images made more violent by the perceived presence of tranquility. In their accounts of human terror in the face of catastrophic natural forces, it is the emotional engagement of Romantic paintings that overrides their narratives and remains foremost in this significant assemblage of European and American storm paintings.

Tempests and Romantic Visionaries: Images of Storms in European and American Art is an examination of Romantic art based on the storm motif, organized in four sections: Dutch seventeenth-century paintings as influential historical reference; paintings by early nineteenth-century Romantics; works by Hudson River painters; and their successors, Thomas Moran and the works by post-Romantics who probed more deeply the turbulence of the human psyche.

The great Romantic marine painters owe much to seventeenth-century Dutch painters who lived and worked in an environment dominated by the sea and an economy that depended on seafaring. Yet, however deep the kinship of the Dutch painters with the sea, in their storm paintings, they were shaped by the idea of destructive forces, not only in nature, but also in society, and in each man. The rock-laden shoreline and sea, opposites it would seem, could be perceived as a united threat. The possibility of capsizing at sea, as opposed to seeking shelter along savage rocky coasts, was often no less disastrous. In Dutch paintings, the informed perfection in rendering ships, including rigging lines and hulls, demonstrated great detail along with strong design, and accomplished craftsmanship. As well, given that much of Holland was actually below sea level, the flatness of land causes the sky to appear a dominant element. These, with atmospheric skies of moisture, ocean air, and magnificent clouds, shaped Dutch seascapes which became the models for nineteenth-century Romantic painters in search of inspiration.

Early in nineteenth-century Europe all sectors of the arts were breaking free from discipline, reason and convention, heeding, instead, emotion and inspiration, intuition, and passion. Painting as an imitation or chronicle gave way to painting as imagination and possibility. "Even in the face of nature, it is our imagination that creates the painting," noted Eugène Delacroix in his diary. Ludwig van Beethoven, one of the great innovators of the crossover point of classical to the Romantic, turned to the storm motif in his Sixth Symphony. Shunning conventions, he composed five movements rather than four, interrupted the traditional classical minuet by the insertion of a violently

orchestrated storm, and, in place of the usual brisk conclusion, composed one of most sublime musical moments, the *Shepherd's Song and Grateful Thanks* as the calm after the storm. Here, as with his contemporaries in literature and art, could be found a Romantic's elevation of beauty to the realm of the sublime. Their compositions, filled with antagonisms so opposed in movement, form, and texture, achieve an essential kinship and harmony that in the end, is deeper than their differences. By invoking more emotional intensity, and by their quest for vastness, infinity, and transparency, they pursued the sublime as superhumanness. Surely, the profound portrayals of storm or calm were personal metaphors, acknowledging the sense of the divine and the sacred power of nature. In the guise of storms, the early Romantic paintings may portray man as frail in the face of the forces of nature (or "in the face of natural forces").

As many American artists traveled to Europe to study European subjects, the British born Thomas Cole, curious about the picturesque and unspoilt regions of the Catskills, made frequent summer trips to the area. Americans, conscious of the important role art, literature, and music played in Europe, especially in Paris, were anxious to establish a similar recognition for their importance in the United States, readily acknowledging their potential contribution to national life. With the development of art schools, museums, and galleries, painters could study and create, but they depended on the support of entrepreneurs and businessmen who were prepared to promote a sense of their own history. In this favorable artistic climate during the 1820s, Thomas Cole founded the Hudson River School, which includes some of the most talented landscape painters of the period. Centered in New York City near its patrons, artists of the school painted according to a codified standard of idealized naturalism that was stylistically and socially coherent. Cole's paintings, highly influenced by those of the British artist J.M.W. Turner, reflected the current philosophical theory on the Sublime in nature. And in the paintings of the Hudson River School, there was the sense of the vulnerability of the American wilderness, threatened by settlement and industry, yet bound by the inevitable power and authority of nature and God. Like the European Romantics, the Americans were fascinated with storms, finding limitless possibilities for expressiveness. Although some, like John F. Kensett painted storms as giving and restorative, others painted storms as avenging, violent forces, symbols of the destructive force of nature against man. Later in the century, the romantic tradition in American landscape painting, as carried on by Jasper Cropsey, Winslow Homer, and Thomas Moran, would continue to turn to the storm motif as source for drama and deeper emotional expression. As Cropsey observed, "in its grandest moods, the storm cloud is more impressive than all the other clouds...awakening the deepest emotions of gloom, dread, and fear; or sending thrilling sensations of joy and gladness through our being." The Americans, too, had captured the sublime.

If imagination played the role of a sort of mediator between man and nature in Romantic painting, the common thread of this exhibition, then exploration of nature was a key to imagination. The storm motif offered a means of exploring the heroical and shortcoming of the human character and the triumphs of scientific explorations, which led to the steam engine, electricity, and the camera. Regardless, what remained then and continues still, is the exploration of the relationship between man and nature. Exceptional examples of this can be found in this exhibition.

The project was the idea of Museum Chief Curator Hardy S. George, Ph.D. whose scholarship and high standards are expressed by his enthusiasm for this subject. Many have contributed to its success, principally, Dr. George, who led the organization of the exhibition and catalogue, and Lindsay Hightower, his invaluable curatorial associate. He extends special thanks to Alison Amick,

Matthew C. Leininger, Jim Meeks, Ernesto Sánchez Villarreal, Christina Busche, Chandra Boyd, Nicole Emmons, John Calabrisi, Alison Barnett, and Doris McGranahan for their roles in presenting the show. For their work in funding and marketing the exhibition and catalogue, we extend our gratitude to Jim Eastep, Leslie Spears, Brad Armitage, and Christen Conger. To all others at the Oklahoma City Museum of Art; including Jeffrey Musslewhite, and Jeanne Parkhurst, who helped in the organization of the project, our thanks. The enthusiastic support of the Exhibitions Committee and the Board of Trustees is especially appreciated. Special thanks also to Dr. Lawrence Goedde, Professor of Art History and Chair of the McIntire Department of Art, University of Virginia; Dr. Geoffrey Quilley, Curator of Maritime Art at the National Maritime Museum, London; Dr. Daniel Finamore, Russell W. Knight Curator of Maritime Art and History, Peabody Essex Museum; and Dr. Mark Mitchell, Assistant Curator of Nineteenth-Century Art, National Academy Museum, New York, for their essays, which have contributed significantly to the catalogue. Catalogue copy editor Jeffery J. Pavelka, and Eric Anderson, catalogue designer and professor of art, University of Oklahoma deserve special thanks for their assistance, as well. The many lenders, including major North American museums and the Tate Britain, London, and National Maritime Museum, London, whose generosity and support were given to make the exhibition and catalogue possible, are most gratefully acknowledged.

Finally, the Insasmuch Foundation is most sincerely recognized for its leadership role as the Museum's Presenting Season Sponsor. Grants from the Oklahoma Arts Council and the National Endowment for the Arts, and a generous anonymous donation are greatly appreciated. For the invaluable partnership of leading season sponsors, Chesapeake Energy Corporation, GlobalHealth, and MidFirst Bank, we offer our profound thanks. For important season sponsorships of the Bowers Foundation, Cox Communications, Inc., Devon Energy Corporation, Kerr-McGee Corporation, and The Oklahoman, we offer our deepest appreciation. We acknowledge, as well, Sarkeys Foundation and Sonic, America's Drive-In, for their generous support given through arts education endowments.

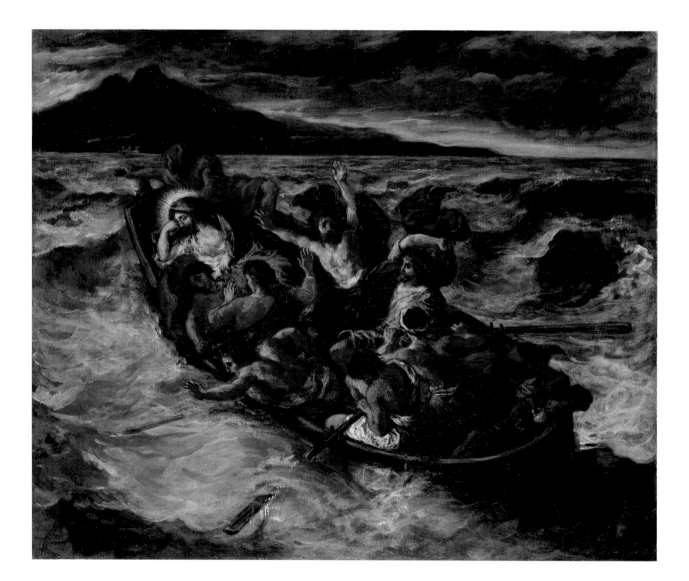

Eugène Delacroix (French, 1798-1863)
Christ Asleep during the Tempest, n.d.
Oil on canvas, 20 x 24 in.
The Metropolitan Museum of Art, H.O. Havemeyer Collection,
Bequest of Mrs. H.O. Havemeyer, 1929

The Moralization of Shipwreck

ca. 1770-1830

GEOFFREY QUILLEY

The cultural and visual representation of shipwrecks in the late-eighteenth and early-nineteenth centuries provides ample evidence of their national and political significance, beyond their local value as records of specific disasters. Above all, their persistent inclusion as a political metaphor in caricature and political satires throughout this period testifies to the national and moral connotations of the subject, invoking the idea of the "ship of state" on a course towards destruction. This is frequently attributed to either governmental maladministration or corruption, or else to general moral decline and descent into luxury.[1] Equally, it is easy enough to see the moral and philosophical import of Biblical storms and shipwrecks as subjects for art, for example Eugène Delacroix's *Christ Asleep during the Tempest* (cat. 22; p. 10) or John Martin's *The Deluge* (cat. 44; p. 13). While such larger, general significance for shipwreck was true for all Atlantic cultures at that time, and beyond, it had particular salience for a Britain that was increasingly self-styled as a maritime imperial nation, with supposedly a special, divinely sanctioned affinity with the sea.[2] Similarly, it applied not just to overtly political or elevated Biblical or literary subjects, but to much more prosaic and mundane accounts. In this essay I want to examine how the subject of shipwreck was moralized through its literary representation, particularly in shipwreck narratives, and how this in turn related to its visual representation during the Romantic period.

That Britain was a commercial nation reliant upon its navy and merchant shipping was, at least by the mid-eighteenth century, a truism that could simply be taken for granted and was underpinned by the belief that the natural and best interests of Britain were tied to the sea. As John Entick asserted in 1757:

> By Navigation the whole World is connected, and the most distant Parts of it correspond with each other. And it is this Correspondence which introduces new Commodities, and propagates the most advantageous Manufactures.

The British state of prosperity, and the refinement of its arts and manufactures, were thus entirely owing to commerce and the exploitation of the sea:

> It is Navigation that has realized and secured us to these Advantages, which Nature has invested us with by our Situation in the Midst of the Ocean. By this Art every little Port, Inlet and Creek opens a Passage for what we want to send abroad, and an Entrance for what we would bring home ... So that Navigation may be considered, as the Channel through which all our Commerce circulates. And from hence we must perceive of how great Importance it is, that it should be free and undis-

turbed: That whatever clogs or obstructs it, must be "an universal Detriment; and that whatever promotes Navigation must be allowed to promote the general Interest of the Nation: For thereon depends our Trade; and upon our Trade depends the Value of our Houses, Lands and Produce.[3]

The impediment caused by shipwreck, therefore, must be "an universal Detriment" of a singularly catastrophic kind, not just for those individuals directly concerned, but for the nation as a whole.

The extended ramifications of shipwreck and its moralization in early-modern culture are most discernible in literature, obviously; for example, in novels such as *Robinson Crusoe*. However, undoubtedly the most popular contemporary literary representation of the subject is William Falconer's *The Shipwreck*, one of the most enduringly popular of all eighteenth-century poems. First published in 1762, it had run by 1802 to eleven editions. Increasingly, from the 1790s, these were illustrated.

Divided into three cantos mixing epic Augustan structure with a nautical vocabulary, so specialized as to require extensive commentary, the poem tells the story of the merchant ship *Britannia*, sailing from Crete to Venice. On board is Palemon, son of the merchant owner of the vessel. Commanded to join the voyage by his father, he sails out of filial duty rather than personal desire, for it forces him to part with his true love Anna. When the *Britannia* is wrecked, Palemon with his dying breath asks for his unswerving devotion to be communicated to Anna. On the surface, therefore, it is a simple story, like *Romeo and Juliet*, of the thwarting of true love by familial duty and overweening commercial ambition. Yet this is extrapolated into a more wide-ranging discourse on national morality. The ship, as its name suggests, obviously stands as a generic sign for Britain, and the major theme of the poem may be taken as a schematic warning about the hasty pursuit of wealth and empire:

Of fam'd Britannia were the gallant crew,
And from that isle her name the vessel drew.
The wayward steps of Fortune, that delude
Full oft to ruin, eager they pursu'd;
And, dazzled by her visionary glare,
Advanc'd incautious of each fatal snare (p.12)

The Augustan epic form is interleaved with an autobiographical account of shipwreck more akin to the voyage narrative, and its popularity needs to be placed against the wider, increasing cultural interest in maritime disaster demonstrated by the rise in published shipwreck narratives at that time. These were published accounts of actual wrecks, usually ones that happened within recent memory but also important historic disasters; and the period 1781-1812 saw over fifty percent more of them than the previous eighty years.[4] This may be taken as part of the general rise in print culture, and more particularly, the increased publication of sensational novels and the literature of sensibility.[5] It also implies a ready market for such accounts. This is further supported by the fact that the same period saw a wholly new development in the shipwreck narrative: the publication of large compilations of tales of marine disaster, often running to many volumes, and like *The Shipwreck* increasingly illustrated with engravings or mezzotints. While compilations of voyage narratives had a history going back to Hakluyt and Purchas, this exclusive attention to shipwreck was new.[6]

Falconer's poem is a tale of the conflict of private affections with public duty, in which the sentimental narrative gradually supersedes the attention to technical nautical detail. This is emphasized in the concluding pathetic scene of Palemon's death on the shore, in which he expresses his undying love for Anna, and with his last breath enlists Arion, the narrator of the poem, to bear her the news of his death. The poem thus shares the same increasing tendency that is a feature of the shipwreck narrative: to show less concern with the technical aspects of maritime crisis, such as the handling, rigging, broaching, and break-up of the

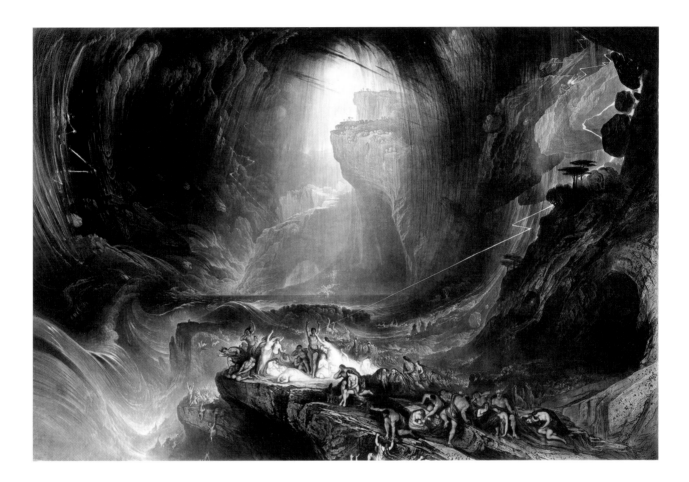

John Martin (British, 1789-1854)
The Deluge, ca. 1828
Mezzotint on india applique, 26¹³⁄₁₆ x 35⅞ in.
Georgia Museum of Art, University of Georgia; University Purchase

ship, and more with the emotional and psychic impact of the catastrophe upon the passengers and crew.

In turn, this shift towards the human interest element was meant to trigger the sensibilities of the reader or viewer. Archibald Duncan advertised the moral benefits of the lessons to be learned from shipwreck narratives in his highly successful six-volume *Mariner's Chronicle*, published between 1804 and 1808. The aim of his compilation was "to rouse the dormant sensations of sympathy and benevolence," through narratives which "are of such a tendency as to excite those emotions of tenderness, those tears of sympathy. If but one heart, hitherto insensible to the appeals of suffering humanity, is led, by the perusal of these pages, to augment the number of the benevolent, the Editor will be more than satisfied."[7] The tendency of shipwreck narratives to instill the virtues of human sympathy was related by another compiler directly to the function of the novel, with a consequent potential to appeal to a more heterogeneous readership, including women.[8]

It was axiomatic in eighteenth-century thinking that art and literature could arouse the sympathetic imagination of the viewer or reader, particularly through the presentation of scenes of pity or distress, which, by their being experienced vicariously at an aesthetic remove, could instead induce the pleasure of being morally uplifted. For Henry Home, Lord Kames, the passion aroused by "an object so powerful as to make a deep impression," mediated by art, was "*the sympathetic emotion of virtue*; for it is raised in the spectator, or in a reader, by virtuous actions of every kind, and by no other sort." Certainly, shipwreck was recognized as a highly appropriate "theatre" for the exercise of the "passion of duty," and its representation, in narratives and pictures, provided a ready subject of "some grand and heroic action," to provoke the "sympathetic emotion of virtue" in the loyal subject of the maritime nation.[9]

A dominant topos of the narratives is the conflict between private desire and public duty. Often they identify, both openly and by implication, treachery as the cause of the disaster, and conflate treacherous behavior with individual physical or mental degeneracy. Among the first of Duncan's narratives is the story of "The Sufferings of Part of the Crew of the Ship *Thomas*, of Liverpool, Bound from the Coast of Africa to the Island of Barbadoes, in 1797." The *Thomas* was a slaver undertaking the final leg of the "triangular trade" of Atlantic slavery, at a dangerous time in the war against revolutionary France. In the narrative, the officers, in order to prepare against potential attack from French privateers, teach the male slaves the use of firearms. Predictably enough, however, instead of defending the ship, the slaves use their weapons to mutiny.[10] Twelve of the crew, displaying the lack of social sympathy and comradeship that was notoriously the product of the slave trade, make off in the ship's boat, abandoning their captain and shipmates to their fate. The deserters pay a diabolical price for their actions. After drifting for days with no sustenance other than "a small turtle," and "their shoes, and two hairy caps" soaked until edible, they cast lots to decide which of them should be eaten. The victim requested to be bled to death, an operation performed by the surgeon, who was one of the group:

No sooner had the fatal instrument touched the vein, than the operator applied his parched lips and drank the blood as it flowed, while the rest anxiously watched the victim's departing breath, that they might satisfy the hunger which preyed upon them. Those who glutted themselves with human flesh and gore, and whose stomachs retained the unnatural food, soon perished with raging insanity, from putrefaction having, it is supposed, superseded digestion. Thus the dreary prospect became still more terrible to the survivors, who beheld their companions expire from the very cause which they imagined would preserve their existence.[11]

Other narratives deal similarly with cannibalism, treating it not as a desperate means of survival so much as a mark of savagery and providential punishment.[12]

Alternatively, shipwreck could provide the arena for acts of heroism and courage of precisely the sort demanded by Kames. Certain shipwrecks were widely known as *causes célèbres*, such as those of the *Grosvenor East Indiaman* (1782), the *Halsewell* (1786) or the *Earl of Abergavenny* (1805). All these were the subject of extensive narrative descriptions, verse accounts and pictorial representations. Such subjects fulfilled not only Kames' stipulations for heroic and powerful subjects, but also the parallel need to elicit the compassion of the viewer or reader. To the same extent that distress and suffering in the world were held to be necessary for the exercise of the virtue of pity, shipwreck could be seen as the necessary corollary to commercial and maritime expansion. The compensation for its disastrous effects was to elicit and strengthen the bonds of sympathy and the sense of national community among its observers: "The fate of the adventurous seamen … cannot be indifferent to those who remain at home, enjoying that security, and those conveniences, which his exertions so materially contribute to procure."[13]

It is against this backdrop that the visual depiction of shipwreck needs to be placed, from humble engraved illustrations for published narratives to large-scale painterly treatments such as J.M.W. Turner's magnificent oil painting *The Shipwreck* of 1805 (fig. 1), which drew directly on the celebrated recent wreck of the *Earl of Abergavenny*.[14] Thus the numerous paintings and prints of shipwreck by Claude-Joseph Vernet (cat. 73; p. 17), Philippe-Jacques de Loutherbourg (cat. 42; p. 19), George Morland (cat. 55) and others as a general rule treat it as a scene of human distress and sentimental compassion. This is dramatically emphasized through a compositional reliance on heavy contrasts of light and dark, sweeping recessions of pictorial space, dynamic linear movement in the treatment of sea and sky, fantastical thrusting ominous forms of rock and shoreline,

Fig. 1
J.M.W. Turner (British, 1775-1851)
The Shipwreck, exh. 1805
Oil on canvas, 67⅛ x 95⅛ in.
Clore Gallery, Tate Gallery, London / Art Resource

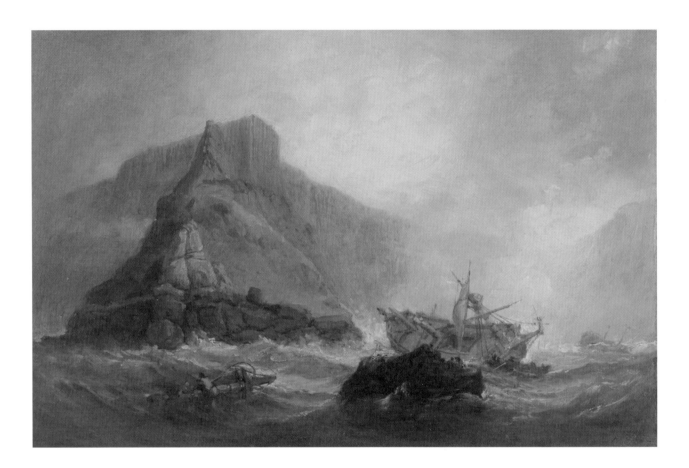

Clarkson Stanfield (British, 1793-1867)
Shipwreck off a Rocky Coast — Savona, n.d.
Oil on panel, 8³⁄₁₆ x 12⅞ in.
The Beaverbrook Art Gallery, Fredericton, NB, Canada,
Gift of the Second Beaverbrook Foundation

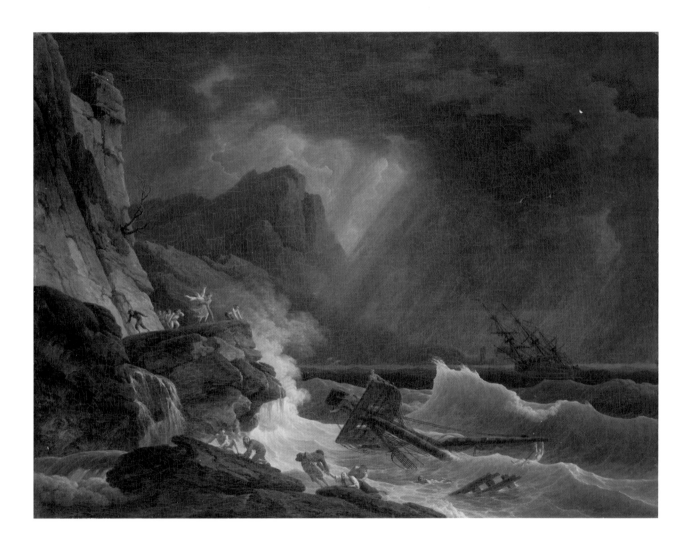

Claude-Joseph Vernet (French, 1714-1789)

The Storm, 1787

Oil on canvas, 45 x 59⅝ in.

Wadsworth Atheneum Museum of Art, Hartford, CT

The Ella Gallup Sumner and Mary Catlin Sumner Collection Fund

and exaggerated melodramatic effects of light. In these pictorial techniques such works are undoubtedly indebted to the representation of shipwreck in contemporary theatre. Loutherbourg's *The Smugglers Return* of 1801, in particular, is a compositional adaptation of his earlier painting *The Shipwreck* of 1793 (fig. 2). This in turn was surely related to the scene of shipwreck in his celebrated *Eidophusikon*, a theatrical entertainment of "moving pictures," employing transparencies and intricate light effects.[15] Loutherbourg, of course, also made his name in London as the leading scene painter for the actor-impresario David Garrick.

Along with the increased publication of shipwreck narratives, the London theatre, perhaps mediating cultural anxieties surrounding the war against revolutionary France, staged an increasing number of plays at the same period on similar themes: S. Birch's *The Smugglers*, which opened on 13 April 1796; James Cobb's *The Pirates* (21 November 1792); *The Shipwreck; Or, French Ingratitude* (27 May 1792); *The Shipwreck* (10 December 1796); and *The Shipwreck; or, Walking Statue* (11 November 1789).[16] The only recent theatrical precedent in London had been Henry MacKenzie's 1783 *The Shipwreck*, an adaptation of George Lillo's *Fatal Curiosity*.[17] There were, of course, also works in the standard repertoire that contained scenes of shipwreck, such as Shakespeare's *The Tempest* or *The Winter's Tale*, and which were also subjects for artistic representation, such as that by Samuel Middiman (cat. 45; p. 20). Undoubtedly, Loutherbourg's, Morland's, and other artists' dramatic and sentimental visualizations of shipwreck were closely related to its theatrical representation.

As the interchangeability and overlap between the subjects of shipwreck, wrecking, and smuggling in Loutherbourg's or Morland's work suggest, shipwreck was further moralized in this period by being associated or elided with those two illegal and subversive activities. Wrecking, though it seems to have been largely mythological, was particularly notorious, characterized in numerous tales and pictures as an act of unmitigated immorality committed by

Fig. 2
Philippe-Jacques de Loutherbourg (British, 1740-1812)
The Shipwreck, 1793
Oil on canvas, 43³⁄₁₆ x 63 in.
© Southampton City Art Gallery, Hampshire, UK / Bridgeman Art Library

Philippe-Jacques de Loutherbourg (French, 1740-1812)
The Smugglers Return, 1801
Oil on canvas, 29 ¼ x 42 in.
Joslyn Art Museum, Omaha, Nebraska,
Gift of Mr. and Mrs. Arthur Wiesenberger

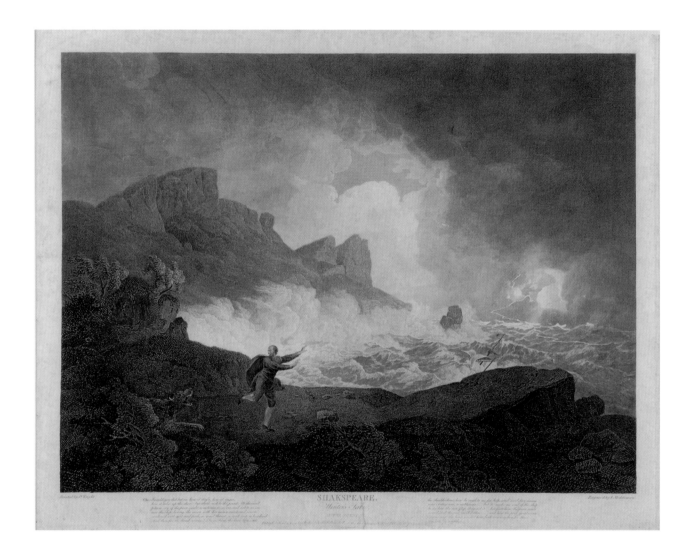

Samuel Middiman (British, 1750-1831)

Scene from Winter's Tales by William Shakespeare, 1794

Engraving, 19½ x 25½ in.

Oklahoma City Museum of Art, Gift of Mr. and Mrs. Martin Wiesendanger

unscrupulous, murderous thieves. These supposedly would happily await the wreck of a ship, or even draw it onto the rocks by using false lights, in order to plunder it and its passengers and crew, stopping at nothing, including the murder of the survivors, to achieve their nefarious end.[18] The grotesque barbarity and savagery of wrecking was also associated with environment, being popularly identified with the wild, harsh, and distant coasts of Cornwall, Wales, and the Scilly Isles; regions whose communities were seen as intractable and socially retrograde.[19] Wreckers were taken to be the products of their remote and brutalizing environment. Thus their criminal activity could be directly analogized with the sublimity of the landscape. One description of the Lizard peninsula in Cornwall made this correspondence explicit, moralizing the coastal landscape.

> The neighbourhood is sadly infested with the Wreckers. When the news of a wreck flies around the coast, thousands of people are instantly collected near the fatal spot … The moment the vessel touches the shore she is considered fair plunder, and men, women, and children are working on her to break her up night and day. The precipices they descend, the rocks they climb, and the billows they buffet, to seize the floating fragments, are the most frightful and alarming I ever beheld … The view of the cliffs and promontories, for nearly three miles on the coast, is tremendous and sublime, far exceeding in romantic grandeur the rocks at Land's End. The sea-gulls, curlews, and murricks, those sole inhabitants of the frightful precipices, contribute to the awful scenery; while the roaring of the winds through the caverns beneath, and the foaming of the billows against the shore, perfected a scene that is scarcely to be paralleled for sublimity and terror. My heart sunk within me at the affecting anecdotes of our guide. O, what tales of woe did he unfold! of wrecks and mangled corpses, death and graves! How did we shudder while he pointed out the frightful rocks on which they struck! I feel even now, while reciting these circumstances, a cold chill, similar to that produced by his pointing to the innumerable graves and pits into which the ill-fated mariner, or delicate passenger, has been thrown; frequently would the tear start from my eye, while passing over those regions of death; and often would my bursting heart exclaim, 'Good God, what has sin done!'[20]

The "frightful precipices" which the ships struck were of course the same "frightful" and "alarming" precipices, rocks, and billows that the wreckers defied "to seize the floating fragments," and there is a clear metonymic relation supposed here between the "awful scenery" and the "horrid system" of wrecking. All the rhetorical devices of the text further impress the inhuman otherness of the environment and the barbarity of its inhabitants. The "roaring of the winds" and "foaming of the billows" provide a pathetic fallacy for the invocation of " unparalleled … sublimity and terror." This leads to the conclusion that contemplation of the coast would induce tears and "often would my bursting heart exclaim, 'Good God, what has sin done!' " A clear correlation is thus established between the character of the landscape and original sin in general, and the local proclivity for the sin of wrecking in particular.

Similarly, the coastal topography depicted by Loutherbourg or Morland is characterized by harsh angularities, emphasizing its inhospitable incapacity for any form of cultivation or benign human manipulation. The castle atop the cliff in Loutherbourg's *The Smugglers Return* in addition bears a close resemblance to his views of Conway Castle on the coast of Wales, reinforcing the association of coastal crime with the harsh, remote topographies of Britain.[21] Shipwreck imagery in general usually features such confrontation with a hard, alien, barren landscape, and thus

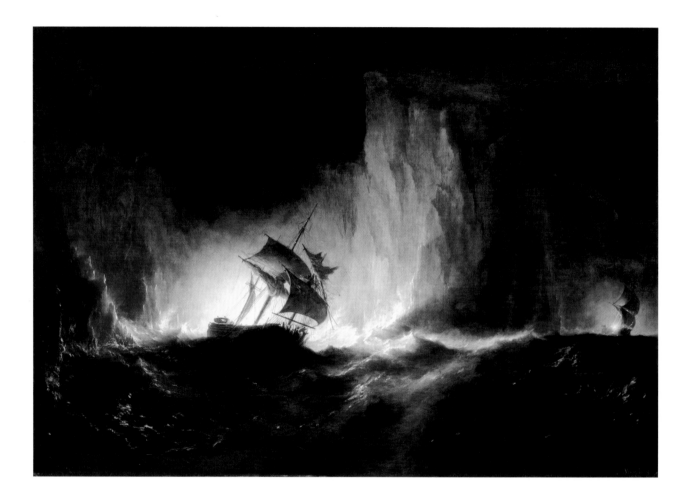

Admiral Richard Brydges Beechey (British, 1808-1895)
HMS Erebus *passing through the chain of bergs 1842*, n.d.
Oil on canvas, 31 x 44 in.
National Maritime Museum, London

with the moralized overtones that implies. Similar moralization might apply at a secondary level even to imagery purporting to be directly documentary, as a visual record of a particular voyage: the high melodrama of Admiral Richard Brydges Beechey's *HMS* Erebus *passing through the chain of bergs* (cat. 1; p. 22) though memorialising a particular event, also certainly draws on a longstanding iconographic tradition relating to the passage of the ship (of "life" or "state") through an inhuman and alien environment.

What emerges consistently from the moralization of shipwreck is the larger symbolic meaning of the ship as a metaphor for the nation, struggling against hostile forces to preserve its order and integrity to reach its goal. In one sense we may see the representation of shipwreck as an attempt at recuperation, an extreme display of virtue in distress, and of heroism in adversity, that serves to reinforce central ideological values to the articulation of the identity of the maritime nation. In another sense, we may see it as an admonition to the nation concerning the consequences of abandoning those values. The image of shipwreck, therefore, particularly when tied to the literary narrative account, with its invocation of social values of sympathy and sensibility, held up a mirror to the maritime-imperial state and its self-identification with the sea and navigation; in that, to return to Entick's words: "whatever clogs or obstructs it, must be an universal Detriment; and that whatever promotes Navigation must be allowed to promote the general Interest of the Nation."

Endnotes

[1] Among countless examples, see *The Pillars of the State* (1768), which relates the state suppression of the Wilkite riots of the late 1760s directly to the image of *Britannia*, the ship of state, wrecked upon the rocks of tyranny; or else James Gillray, *The Storm Rising;-or-The Republican Flotilla in Danger* (1798), a complex print that shows William Pitt personifying the force of a storm attempting to sink a French republican invasion raft, against the effort of treacherous British democrats, who try to winch the vessel to safety.

[2] See Geoff Quilley. "'All Ocean is her own': The image of the sea and the identity of the maritime nation in eighteenth-century British art." In Geoffrey Cubitt, ed. *Imagining Nations*. Manchester: Manchester University Press, 1998: 130-54.

[3] Entick, John. *A New Naval History: Or, Compleat View of the British Marine*. London, 1757: i.

[4] Huntress, Keith. *A Checklist of Shipwrecks and Disasters at Sea to 1860*. Ames: Iowa State University Press, 1979.

[5] Raven, James. *Judging New Wealth: Popular Publishing and Responses to Commerce in England, 1750-1800*. Oxford: Clarendon, 1992.

[6] On the history of the voyage narrative, see G.R. Crone and R.A. Skelton. "English Collections of Voyages and Travels, 1625-1846." In E. Lynam, ed. *Richard Hakluyt and his Successors*. London: Hakluyt Society, 1946: 63-140; Philip Edwards. *The Story of the Voyage: Sea-Narratives in Eighteenth-Century England*. Cambridge: Cambridge University Press, 1994.

[7] Duncan, Archibald. *The Mariner's Chronicle; or, Authentic and Complete History of Popular Shipwrecks: Recording the Most remarkable Disasters which have Happened on the Ocean to People of all Nations. Particularly the Adventures and Sufferings of British Seamen, by Wreck, Fire, Famine, and other Calamities incident to a Life of Maritime Enterprizes. By Archibald Duncan, Esq. Late of the Royal Navy. In Six Volumes*. London: J. Cundee, n.d., vol.1: iv-v.

[8] Clarke, James Stanier. *Naufragia or Historical Memoirs of Shipwrecks and the Providential Deliverance of Vessels by James Stanier Clarke F.R.S. Chaplain of the Prince's Household and Librarian to His Royal Highness*, 2 vols. London: J. Mawman, 1805-1806, vol. 2: vii.

[9] Home, Henry and Lord Kames. *Elements of Criticism*, 2 vols., 6th edn. Edinburgh and London: John Bell and William Creech and T. Cadel and G. Robinson, 1785, vol. 1: 44, 62-4.

[10]Duncan, op. cit.: 90-3.

[11]Ibid.: 91-2.

[12]See, for example, the narrative of the loss of the Peggy sloop, discussed in Edwards, op. cit.: 217-18.

[13]Duncan, op. cit., vol.1: iv.

[14]Venning, Barry. "A Macabre Connoisseurship: Turner, Byron and the Apprehension of Shipwreck Subjects in Early Nineteenth-Century England." *Art History* 8/3, Henley-on-Thames, 1985: 303-19.

[15]On the *Eidophusikon* see Rüdiger Joppien, *Philippe-Jacques de Loutherbourg, R.A., 1740-1812* (exhibition catalogue). London: Kenwood, 1973.

[16]For theatre productions see C. B. Hogan. *The London Stage 1660-1800*. Part 5: *1776-1800*. 3 vols. Carbondale: South Illinois University Press, 1968.

[17]Ibid., vol. 2: 638, 679-80.

[18]Rule, J. G. "Wrecking and Coastal Plunder." In Douglas Hay, Peter Linebaugh, and E.P. Thompson, eds. *Albion's Fatal Tree: Crime and Society in Eighteenth-Century England*. London: Allen Lane 1976: 167-88; who points out the lack of any firm evidence of the use of false lights to lure ships onto the rocks.

[19]Ibid.: 169-73.

[20]Smith, Rev. G. C. *The Wreckers; or, a Tour of Benevolence from St. Michael's Mount to the Lizard Point Interspersed with Descriptive Scenery of Mount's Bay, Cornwall*. London: W. Whittemore, 1818: 8-9.

[21]See, for example, the version in the National Maritime Museum, London: BHC2496.

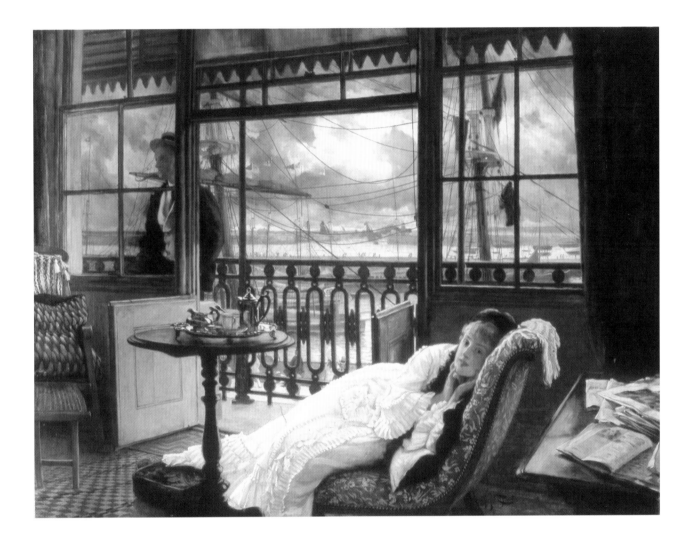

James Jacques Joseph Tissot (French, 1836-1902)
A Passing Storm, 1876
Oil on canvas, 30¼ x 39¼ in.
The Beaverbrook Art Gallery, Fredericton, NB, Canada,
Gift of the Sir James Dunn Foundation

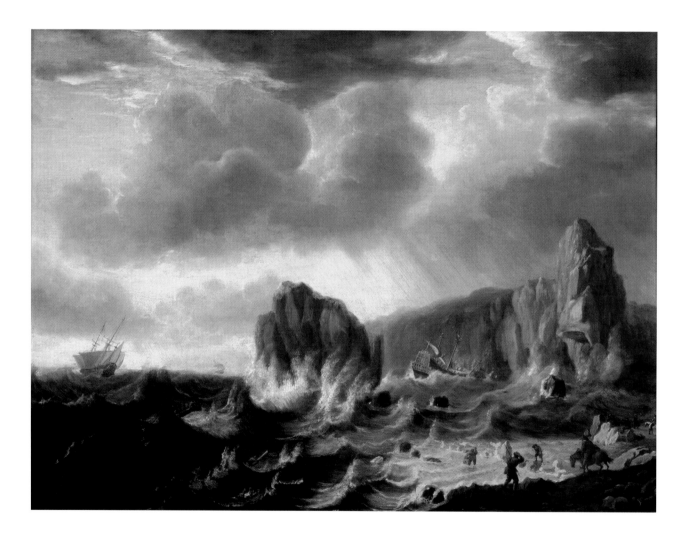

Simon de Vlieger (Dutch, ca. 1601-1653)
A Ship Wrecked off a Rocky Coast, 1640
Oil on panel, 29½ x 40 in.
National Maritime Museum, London
Acquired with the assistance of the National Art Collections Fund

Elemental Strife and Sublime Transcendence: Tempest and Disaster in Western Painting

ca. 1650–1850

Lawrence O. Goedde

The Romantic visual representation of storms and disasters depended on pictorial devices developed in the sixteenth and seventeenth centuries in the Netherlands and Italy. The heightened drama we associate with the storm images of such artists as J.M.W. Turner, Philippe-Jacques de Loutherbourg, John Martin, Gustave Courbet, and Winslow Homer resulted from these artists' appropriating and reworking the compositional structures, dramatic motifs, and expressive effects of these prototypes.[1] Two compositional structures that had already appeared in the sixteenth century were particularly important in this development. One provides a close-up focus on human beings and their emotional and physical responses in situations of extreme peril. In the Renaissance this type was used to illustrate such subjects as "Christ asleep in the storm on the Sea of Galilee" or "Jonah cast to the whale" (fig. 3; p. 28). In the eighteenth and nineteenth centuries these compositions provided the pattern for a new subject that I call the "drama on the deck," a close-up depiction of sailors and passengers in moments of extreme danger and crisis. Turner's *The Wreck of a Transport Ship* (fig. 4; p. 28) and Théodore Géricault's *The Raft of the* Medusa (fig. 5; p. 29) use this compositional type, and Eugène Delacroix's *Christ Asleep during the Tempest* (cat. 22; p. 10) is a late example of the religious subjects for which the type was originally invented.

This close-up compositional type, however, is much less common in the earlier tradition than another that places human beings and their vessels within a much wider vision of the natural world – a shipwreck scene by Simon de Vlieger is a fully-developed picture of this kind (cat. 74; p. 26). Instead of a focus on the figures, images like de Vlieger's make the ships and people small within a panorama of cliffs, waves, and clouds. The effect is to depict the submission of vessels to vastly superior natural forces and to reinforce the vulnerability of those human beings who manage to reach shore or who dare to offer assistance to the shipwrecked.[2] Such images are the ancestors of many works exhibited here, for instance, the pictures by Claude-Joseph Vernet (cat. 73; p. 17) and James Hamilton (cat. 27; p. 32), in which the pictorial devices of artists like de Vlieger, Ludolf Bakhuizen (fig. 6; p. 29), and Willem van de Velde the Younger are heightened to amplify our encounter with human emotion and frailty in the face of overwhelming natural forces. Typically, later artists increased the light and dark contrasts of their seventeenth-century prototypes and emphasized the power of wind and wave even more and their assault on human beings. Hamilton filled the surface of his image with turbulent clouds and waves that threaten to obliterate the vessel, while Vernet also gave greater prominence to the clouds and driving rain making our viewpoint closer to the shore so we can see more clearly the range of emotions displayed by the observers on shore.

De Vlieger's picture is characteristic of Dutch treatments of this subject in that in effect it steps back from the

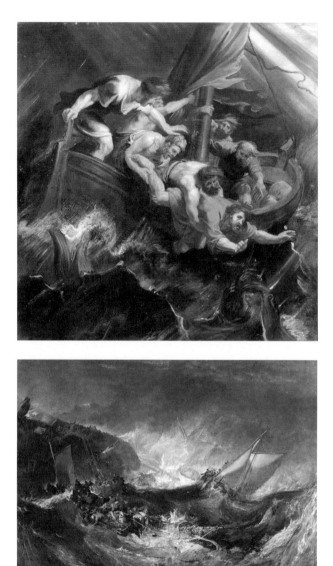

disaster for a wider vision that includes a ship to the left apparently escaping the rocks and also intimations of improving weather in the breaking clouds in the left half of the composition.[3] Even Ludolf Bakhuizen's highly dramatized tempest pictures, in which the artist made the ships larger in the pictorial field than we see in de Vlieger's work, still keep the viewer at a greater distance than Vernet allows, while retaining the suggestion of fair weather in the future. In contrast, Romantic storm scenes place greater emphasis on powerful human feelings and overwhelming natural forces, evincing an important change in tone and content from seventeenth-century images. This same change is also manifest in the elimination of suggestions of salvation and calmer weather found in earlier pictures of these subjects and results from and expresses an altered understanding of human capacity in the natural world and a new conception of the function of the work of art itself.

Before the eighteenth century, depictions of storm and disaster in European art and literature frequently occur in relation to imagery of calm and order. Juxtapositions of tempest and calm intensify Biblical narratives of disaster and storm, which include such familiar accounts as the story of Noah's Ark and the Deluge (Genesis 7-8), the storm sent by God in pursuit of Jonah (Jonah 1:4-7), the shipwreck of St. Paul (Acts 27:13-44), and the tempest (Psalm 107:23-30):

> They that go down to the sea in ships, that do business in great waters; these see works of the Lord, and his wonders in the deep. For he commandeth, and raiseth the stormy wind, which lifteth up the waves thereof. They mount up to the heaven, the go down again to the depths: their soul is melted because of trouble. They reel to and fro, and stagger like a drunken man, and are at their wit's end. Then they cry unto the Lord in their trouble, and he bringeth them out of their distresses. He maketh the storm a calm, so that the waves thereof are still. Then are they glad because they be quiet; so he bringeth them unto their desired haven.

Characteristic of all are vividly compelling accounts of human terror in the grip of natural violence alternating with the joy of rescue from disaster or safe arrival in port.[4] In the classical literary tradition, in genres like epic and romance, tempests and catastrophe alternate with fair weather and harmony as a framework within which the narrative develops.[5] Such literary accounts of storms originate in a tradition going back to Homer and were familiar in the sixteenth and seventeenth centuries in the works of such Roman authors as Virgil, Ovid, and Lucan. In their texts the experience of natural fury and turmoil on sea and land is marked by a highly detailed description in which human beings and their vessels are caught in a situation of extreme peril, where polarities of experience are conjoined and seemingly challenge the order of the universe. Such passages are themselves the extreme opposites of descriptions of fair sailing and happy arrivals in secure harbors. Seafaring and storms also stand in opposition to both the *locus amoenus*, the happy place, of pastoral poetry, as well as to the carefully tilled fields of georgic literature. In the landscapes of pastoral we find a vision of harmony between human desire and the natural world, a context in which seafaring is presented as a sign of the decline of humanity's ideal oneness with nature in the Golden Age. In georgic poetry, which is concerned with agriculture, seafaring and the dangers of the stormy sea are always set in opposition, if only in passing, to the ideal life of industry, fertility, and harmony that the wise farmer can find in nature.[6]

Though the visual arts lacked a comparably ancient tradition of storm and disaster imagery, painters in Italy and the Netherlands developed in the sixteenth and seventeenth centuries a vivid pictorial vocabulary for depicting storms with convincing naturalism and dramatic tension.[7] As in the literary tradition, these artists also tended to conceive their imagery of peril, destruction, and loss as complementary to, or completed by, imagery of calm, security, and prosperity. While actual pairings of stormy seas with calm harbors or peaceful pastoral landscapes rarely survive, paintings that depict paintings on the walls of rooms indicate that such juxtapositions were probably

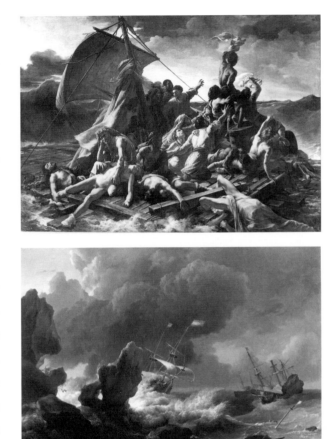

Fig. 5
Theodore Géricault (French, 1791-1824)
The Raft of the Medusa, 1819
Oil on canvas, 193⁵⁄₁₆ x 282⁵⁄₁₆ in.
Musée du Louvre, Paris

Fig. 6
Ludolf Bakhuizen (Dutch, 1631-1708)
Ships in Distress off a Rocky Coast, 1667
Oil on canvas, 45 x 65⅞ in.
National Gallery of Art, Washington, D.C., Alisa Mellon Bruce Fund

Jan van Goyen (Dutch, 1596-1656)
The Thunderstorm, 1641
Oil on canvas, 54¼ x 72⅛ in.
Fine Arts Museums of San Francisco,
Museum Purchase, M.H. de Young Memorial Museum

Pieter Mulier the Elder (Dutch, ca. 1615-1670)
Whaling in Rough Seas, ca. 1640
Oil on panel, 15 x 23⅜ in.
Private Collection, Baltimore

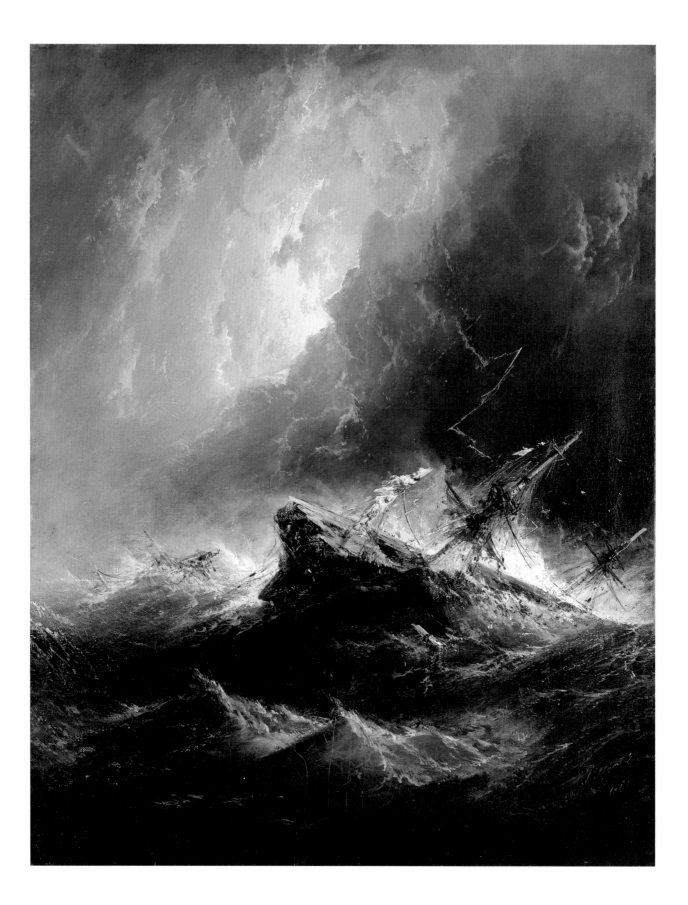

James Hamilton (American, 1819-1878)
Old Ironsides, 1863
Oil on canvas, 60⅜ x 48 in.
Courtesy of the Pennsylvania Academy of the Fine Arts, Philadelphia
Gift of Caroline Gibson Taitt

more common than the meager survivals of paired pictures indicate.[8] Certainly such pairings also came into being adventitiously as collectors hung pictures to produce such conceptual pendants. It is a characteristic feature of Dutch seascape painting that most of these artists produced both stormy and calm pictures. Simon de Vlieger's work, for instance, includes both shipwreck scenes and many images of shipping in brisk weather in local waters or fresh views of beaches with fish markets (fig. 7). It is also striking that artists one associates with scenes of calm, ordered landscapes, like Jan van Goyen (cat. 26; p. 30) and Aelbert Cuyp in the Netherlands, and Claude Lorrain and Nicholas Poussin in Italy, also produced occasional stormy scenes that highlight the harmonious tenor of their more common subjects.[9]

This tendency to conceive and depict storms and disasters in such a way as to imply resolution and order results from a cosmology of elemental harmony and conflict. In this conception of the universe, storms take an assigned place in the processes of seasonal growth, harvest, decay, and renewal, all of which arise from cosmic tensions of compatibility and hostility between the Four Elements.[10] An engraving by Jacob Matham after a design by Jan Wildens (fig. 8) treats the storm as part of a larger structure of seasonal change in which it alternates with scenes of growth and abundance.[11] The text makes this explicit:

> Behold the Pleiades disturb the whole sea in the month of November, and a fierce wave carries off the imperiled ship; seeing which, you would say, "Who has joined together such discordant elements?" In this one place are heaven and black hell.[12]

This image like many other depictions of seasons and months is ultimately based on an understanding of the natural world and humanity's place in it as shaped by the interactions of the Four Elements — Earth, Water, Air, and Fire — as the basic components of all creation. In the theory

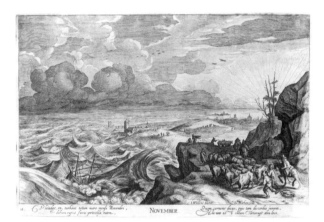

Fig. 7
Simon de Vlieger (Dutch, 1600-1653)
Fish Market on the Beach near Scheveningen, 1633
Oil on canvas, 33¼ x 42 in.
National Maritime Museum, London

Fig. 8
Jacob Matham (Flemish, 1571-1631) (after Jan Wildens, Flemish, 1583-1653)
November, n.d.
Engraving, 11 x 16⅝ in.
© Rijksmuseum-Stichting, Amsterdam

of the Four Elements, conflict and concord are essentially built into the universe because each element is composed of two of the four basic qualities, which exist as two pairs of polar opposites: dryness and moistness, and cold and heat. Because each quality is capable of combining with two of the others but is the opposite of the third, each element in turn is compatible with two elements with which it shares qualities but absolutely contrary to the third. This love and strife of the four elements was a cosmological archetype that defined the structure of the whole cosmos and of every microcosm that reproduces in small the great world, the macrocosm.[13] The universe in this conception functions as an immense network of correspondences, so that the four elements are adumbrated or reflected in the microcosms of the human body as the four humors, in human life as the four ages of man, and in weather as the four winds and on a larger scale the four seasons. All are pervaded by the same tensions of compatibility and polar opposition existing within the embracing unity of the cosmos.

It is this comprehending order in which the storm is one component of a larger cosmic unity that finds expression in the tendency of pre-Romantic storm imagery to be expressed in terms of polarities in which human beings struggle and in some cases escape and in others die. But in either case it is a coherent cosmos in which the conflict of the elements still implies a larger order of resolution in harmony, as every storm implies a safe harbor and most tempest images contain hints of sun, blue sky, and fair weather, however dire the straits in which vessels and their crews find themselves. The more distant, embracing vision of such pictures of disaster depicts neither the total subordination of human beings to the elements nor their obliteration by nature, but humanity's place in a wider cosmic order.[14]

In the later seventeenth and early eighteenth century we find a development away from the earlier vision of the storm, and two somewhat divergent approaches to depicting tempest and disaster became widespread. One is an in-creasing emphasis upon human beings and their emotions in the face of extreme danger. The other engulfs people and ships in natural forces of calamitous scale, so that human beings are threatened with or even experience annihilation. In a subsequent nineteenth-century development, human beings disappear completely from the pictorial field leaving the viewer to confront the furies of nature directly.

The former approach is evident in Vernet's celebrated shipwreck scenes where he built upon the wild surging natural forces seen in landscapes and coastal scenes by Salvator Rosa and the almost histrionic shipwrecks scenes of Pieter Mulier the Younger, known as the Cavaliere Tempesta.[15] Vernet makes the viewer's position more proximate to the scene and amplifies the treatment of waves breaking on wild rocks with blasts of light and driving rain showers from towering clouds to create grandiose natural effects that threaten castaways and rescuers struggling with the waves or responding emotionally to the disasters they witness. The broadly readable gestures of Vernet's figures describe a much wider range of action and emotional response than we typically find in seventeenth-century shipwreck scenes like de Vlieger's. The closer viewpoint and more explicit depiction of physical struggle and emotion encourage increased viewer identification with the beleaguered human beings and their vessels. It is, by the way, important to appreciate the degree to which ships and boats function in marine painting as nearly human objects of identification since they are human creations of great complexity and they respond to both human control and the weather.

The expanded treatment of human actions and feelings in eighteenth-century images accompanies a significant expansion in the variety of situations and subjects depicted in the scenes of storm and disaster from that era.[16] The vast majority of seventeenth-century paintings conform to a relatively limited range of situations, whereas beginning in the eighteenth century we find new subjects appearing such as castaways in boats or on rafts, smugglers or outlaws on

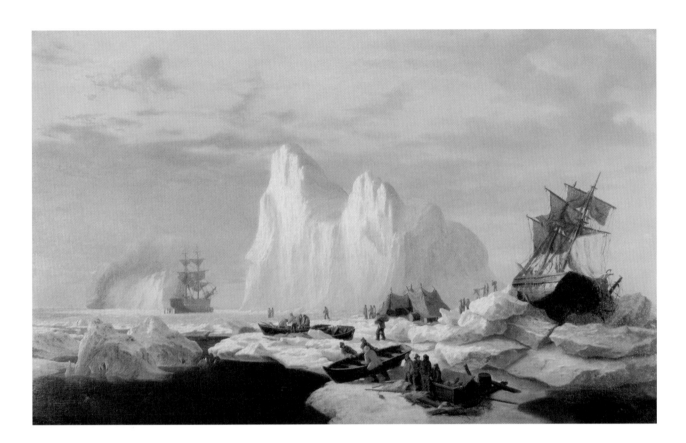

William Bradford (American, 1823-1892)
Caught in the Ice Floes, ca. 1867
Oil on canvas, 27¼ x 44¼ in.
© The New Bedford Whaling Museum

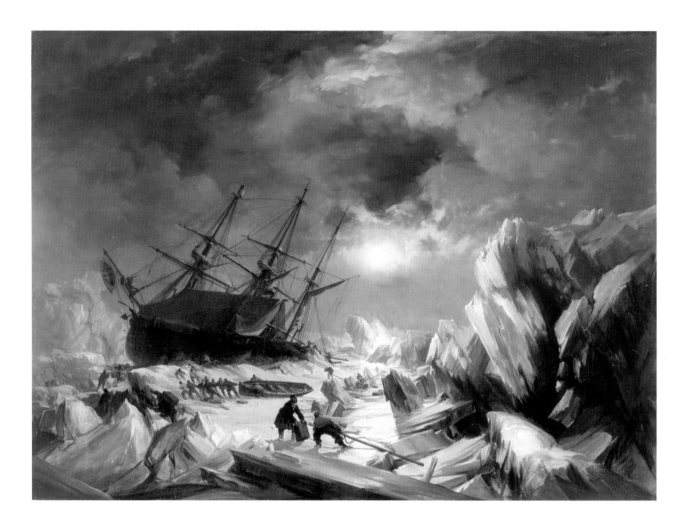

George Chambers (British, 1803-1840)
The Crew of HMS Terror *Saving the Boats and Provisions on the Night of 15ᵗʰ March (1837)*, 1838
Oil on canvas, 23 ¼ x 33 in.
The Beaverbrook Art Gallery, Fredericton, NB, Canada, Purchased with a Minister of
Communications Cultural Property Grant and funds from the friends of the Beaverbrook Art Gallery

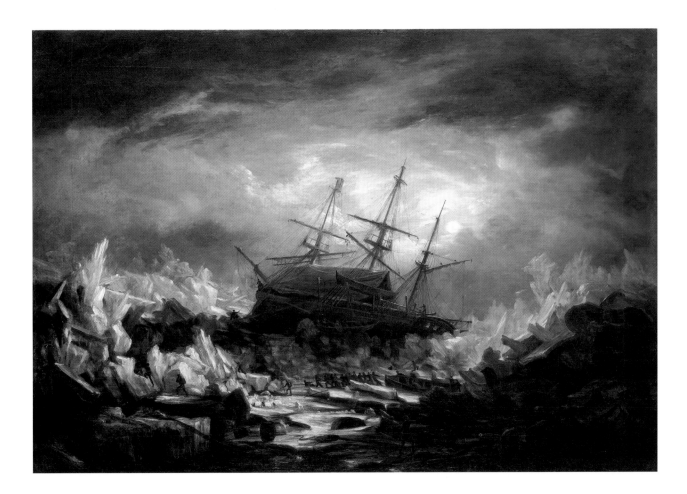

Admiral William Smyth (British, 1800-1877)

Perilous position of HMS Terror,

Captain Back, in the Arctic Regions in the summer of 1837, n.d.

Oil on canvas, 33 x 48 in.

National Maritime Museum, London

Robert Salmon (American, ca. 1775-ca. 1851)
Greenock 1818, n.d.
Oil on panel, 11¾ x 15⅛ in.
Courtesy Susan W. Meade

wild shores (cat. 42; p. 19), imperiled ships in Arctic seas (cats. 5, 11, 64; pp. 35-37), and scenes from literary storms by Shakespeare and other authors (cat. 45; p. 20). Revealingly, many such images portray actual historical events, depicting identifiable shipwrecks, for instance, or scenes of Arctic explorations. In the seventeenth century, storms and shipwrecks are only exceptionally identifiable, and even those images that very likely depict specific events render them in terms virtually identical to the standard generic types.[17] This conforms to a tendency in the early modern era to depict the present in terms of historical types or patterns that confer meaning and legitimacy.[18] In contrast, in the eighteenth and early nineteenth centuries the specificity of the depicted event provided its validation and authenticity. As a result, artists produced ever more detailed and circumstantial depictions of all kinds, including scenes of storms and disasters, even as images became more vividly dramatized and psychologically dynamic.

The intensifying interest in the eighteenth century in pictures encouraging the viewers' projection of emotion very likely lies behind the revival of the close-up compositional type used in prior centuries for religious subjects like "Christ asleep in the storm," now adapted to depict the responses of human beings on decks of sinking ships and of castaways in boats and rafts.[19] Probably the most celebrated picture of this kind (and notably a subject from contemporary life) is Théodore Géricault's *The Raft of the* Medusa of 1819 depicting castaways helplessly drifting at sea.[20] The subject involves the crew of a French government ship that wrecked off the coast of Africa. The officers, taking the few lifeboats, abandoned 150 crewmen and passengers to their fate on a raft. Only fifteen survived after suffering horribly on the raft for thirteen days; of these survivors five died shortly after rescue. Géricault emphasized the physical and psychological effects of the prolonged agony of drifting at sea: death from starvation, thirst, and exposure; despair, madness, and frenzies of hope; and he alluded to cannibalism. Just listing the emotions and sufferings in this image

reveals how different its emotional charge is from Dutch tempest imagery of the seventeenth century. Looking at *The Raft of the* Medusa, we are encouraged to experience the most intense identification with, and compassion for, the "horror and anguish of the men on the raft," as Géricault himself put it.[21] Standing before the huge painting we are turned into near participants since its boards and corpses seem only feet away from us. There is, moreover, no resolution of the conflict between humanity and nature for Géricault chose to depict not the moment of salvation but yet another disappointment as the ship on the horizon departed without rescuing them.[22] Whereas shipwreck in the earlier tradition leads ultimately to meditation on human life within a turbulent and dangerous but divinely ordered and coherent universe, the *Raft of the* Medusa is a highly personal symbol of ceaseless conflict between human will and elemental forces.[23]

Apparently a critical factor in the development of images like Vernet's and Géricault's was the expectation of encountering in storm and disaster the experience of the sublime. This experience involves the direct encounter between an individual intelligence and the overwhelming forces and spaces outside the self, a confrontation experienced both as terror or horror and as a transcendence of human limitation in the face of the awesome and perilous otherness of the world.[24] As the encyclopedist and critic Denis Diderot commented on contemplating a storm by Vernet, "All that astonishes the soul, all that impresses a feeling of terror leads to the sublime. A vast plain does not astonish like the Ocean, nor the tranquil Ocean like the Ocean enraged."[25]

The evocation of this experience of the vast power of the natural world and human smallness in it also leads to an alternative approach to depicting natural perils and disasters in which vessels are diminished in relation to nature. In some cases like Admiral Richard Brydges Beechey (cat. 1; p. 22) and Admiral William Smyth (cat. 64; p. 37) images of ships amid the icebergs and frozen wastes of the Arctic, the

scale of the surroundings to the vessels enhance the dangers men experience in the extreme cold and icy vastnesses of the North. In other cases like pictures by James Hamilton and J.M.W. Turner (cat. 68; p. 50) the swirling forces of the storm seemingly engulf human presence nearly to the point of obliteration. In *The Deluge*, John Martin combines a circumstantial description of unavailing human struggle and anguish amid a cataclysm of overwhelming scale in an enormous canvas – here represented by an engraving, (cat. 44; p. 13) – filled with tempest, torrential downpours, lightning bolts, and collapsing mountains. Every detail communicates the puniness of humanity in the face of titanic natural forces that bring about the near-annihilation of humankind and all life on earth.

In such images the diminished scale and visibility of human beings requires that the beholder confront the catastrophic power of nature in a way that resembles our encounter with the horrific sufferings of humanity up close and at life size in *The Raft of the* Medusa. As different as they are, both kinds of composition demand the viewer's empathic participation in encountering overwhelming situations, requiring our imaginative engagement with natural convulsions and with our frailty and mortality. In other words, the pictures themselves provide the opportunity for experiencing catastrophe and its answering human feelings, and in the process, the representation of calamity and annihilation rather than actual places and real forces of nature becomes the site for the experience of sublimity. The work of art in this way functions as the imaginative equivalent of situations in the natural world and human history that the theoreticians of sublimity identified as providing the experience of the sublime. No doubt encouraging this development was a tendency in the philosophical discussions of sublimity to identify the works of certain authors and artists with the sublime. Shakespeare, for instance, came to be seen as sublime, as did the painters Salvator Rosa and Jacob van Ruisdael.[26]

Fig. 9
Winslow Homer (American, 1836-1910)
Northeaster, 1895
Oil on canvas, 34⅜ x 50¼ in.
The Metropolitan Museum of Art, Gift of George A. Hearn, 1910

The tendency of the work of art to become the locus of intense emotional projection and to serve as the site for the experience of profound identification with natural forces may well explain the development of another new type of marine image, one in which there are no mediating human figures or vessels. In this type we sometimes confront the sea from land as in Winslow Homer's *Northeaster* (fig. 9), where spray from waves crashing head-on towards us fills the left quarter of the pictorial field and in the distance successive waves implicitly rolling forward make vivid the relentlessness of the sea's fury. Gustave Courbet favored this way of treating the waves, with just a bit of beach from which he confronted, and now we do, turbulent waves and clouds filling up most of the pictorial field (cat. 19; p. 71). In other pictures of this kind like Thomas Moran's paintings (cats. 48, 54; pp. 60, 61), neither land nor the deck of a vessel is visible. The imaginative appeal of such works lies partly in their making our position relative to the sea ambiguous. This uncertainty enhances both our sense of immediate encounter with sky, clouds, sunlight, and waves, but also our sense of the unstable power of these elements seen so directly and without framing structures that would clearly locate our place in the world.

The Romantic imagery of raging nature transforms in revealing ways the earlier pictorial traditions on which it is clearly based. From depictions of humanity's place in a divinely ordered cosmos, artists of the eighteenth and nineteenth centuries amplified pictorial devices that make the fury and vastness of nature and human responses to them objects of the most intense psychological projection. In the process pictures, that is, representations, came to possess virtually the same capacity as nature itself to provide the means of measuring ourselves against the sublime terrors of nature and experiencing both our vulnerability and our transcendence of our own mortality.[27] Imagery of tempest and disaster thus participated at a critical moment in the development of the modern conception of the psychologically charged work of art, as well as the modern notion that art has the capacity to make available for personal reflection and confrontation the most profound human experiences of extreme fear and proximity to death, as well as the exhilaration of survival. In so doing depictions of storms became highly personal metaphors for both human life and the experience of art as the site of imaginative transformation and creativity, both essential components of the Romanticism that runs deeply through at least some aspects of the modernist tradition.

Endnotes

[1] For the development of imagery of storm and disaster from the Renaissance to the eighteenth century, see Lawrence O. Goedde, *Tempest and Shipwreck in Dutch and Flemish Art: Convention, Rhetoric, and Interpretation*. University Park and London, 1989, Chapter 3. On seascape and Romanticism, see Lorenz Eitner. "The Open Window and the Storm-Tossed Boat: An Essay in the Iconography of Romanticism." *Art Bulletin*, 37, 1955: 281-90; and W. H. Auden. *The Enchafèd Flood or the Romantic Iconography of the Sea*. New York, 1967.

[2] For the characteristic features of these kinds of images, see Goedde, op. cit.: Chapter 6.

[3] For the scale of ships and people and the inclusion of suggestions of fair weather in Dutch storm paintings, see Goedde, op. cit.: 196-203.

[4] For the sea and storm in the Christian tradition, see Goedde, ibid.: 38-40.

[5] For the classical tradition of tempest narratives, see Goedde, ibid.: 26-31, and M. P. O. Morford. *The Poet Lucan: Studies in Rhetorical Epic*. Oxford, 1967: 20-36.

[6] For the storm and seafaring in pastoral and georgic, see Goedde, op. cit.: 30-1, and the literature cited on p. 213, notes 19-25.

[7] Goedde, ibid.: 47-100.

[8] For paintings within paintings and pendant paintings,

see Goedde, ibid.: 148-61.

[9]The painting by Van Goyen in this exhibition is characteristic of a Dutch type depicting thunderstorms over local waters, and very unlike the vast majority of Dutch shipwreck scenes: Goedde, op. cit.: 97-8, 190-1.

[10]For the relationship between the cosmology of the elements and meteorology, see Goedde, ibid.: 31-5; S. K. Heninger. *The Cosmographical Glass*. San Marino: CA, 1977, esp.: 106-15; and Gerhard Frey. "Elemente." *Reallexikon zur deutschen Kunstgeschichte*, IV: 1256-61.

[11]Jacob Matham, after Jan Wildens, *November*, engraving. B. 230. Walter L. Strauss, ed. *The Illustrated Bartsch*, vol. 4, *Netherlandish Artists: Matham, Saenredam, Muller*. New York, 1980: 207.

[12]November

Pleiades, en, turbant totum mare mense Novembri,

Et dubiam raptat saeva procella ratem,

Quam cernens dicas, quis tam discordia junxit,

Hoc uno est coelum tartaraque atra loco.

I am indebted to Mark Morford for the translation.

[13]Nicolson, Marjorie Hope. *The Breaking of the Circle*, rev. ed. New York and London, 1962: 1-46.

[14]Goedde, op. cit.: 196-206.

[15]Goedde, ibid.: 98-9; Philip Conisbee. *Claude-Joseph Vernet, 1714-1789*. London: Kenwood House, 1976; and idem, "Salvator Rosa and Claude-Joseph Vernet." *Burlington Magazine*, v. 115 (1973): 789-94.

[16]Eitner. "Open Window …": 289.

[17]Goedde, op. cit.: 102-8

[18]Van de Waal, H. *Drie eeuwen vaderlandsche geschieduitbeelding, 1500-1800*. The Hague, 1952, vol. I: 1-17, 50-2.

[19]Boase, T.S.R. "Shipwrecks in English Romantic Painting." *Journal of the Warburg and Courtauld Institutes*, v. 22 (1959): 332-46.

[20]Eitner, Lorenz. *Géricault's Raft of the Medusa*. London, 1972.

[21]Ibid.: 53.

[22]Ibid.: 146-7.

[23]Ibid.: 54-6.

[24]On the sublime and its relation to landscape, see Samuel H. Monk. *The Sublime*. New York, 1935: 1-17, 203-32; Marie-Antoinette Tippetts. *Les Marines des peintres vues par les littérateurs de Diderot aux Goncourts*. Paris, 1966: 42-2, 75-7; Andrew Wilton. *Turner and the Sublime* (exhibition catalogue). Toronto: Art Gallery of Ontario, 1980: 65-105, 145-64; and Roger B. Stein. *Seascape and the American Imagination*. New York, 1975: 40-51, 111-23.

[25]Diderot, Denis. *Salons*, vol. III, 1787, Jean Seznec, ed. 2nd edn. Oxford, 1983: 165. Tippetts. op. cit.: 48.

[26]Monk, op. cit.: 196-210.

[27]Eitner. "Open Window …": 290.

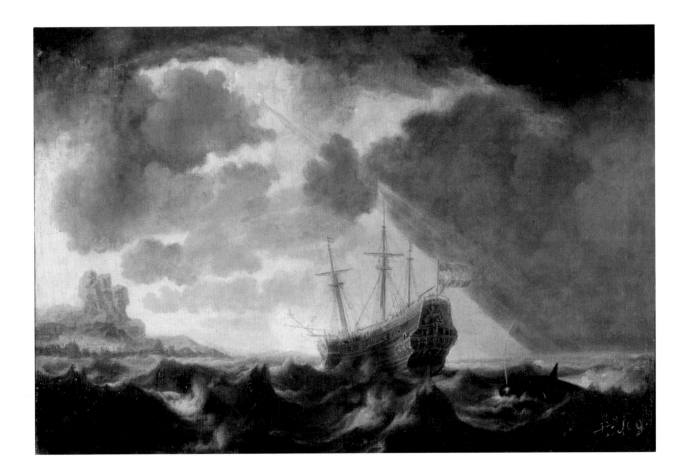

Catherina Peeters (attributed to) (Flemish, 1615-1676)

Ship and Spouting Whale after a Tempest, 1660-1675

Oil on canvas, 14½ x 21½ in.

© The New Bedford Whaling Museum

John Linnell (British, 1792-1882)
The Storm, 1853
Oil on canvas, 35½ x 57½ in.
Philadelphia Museum of Art, John Howard McFadden Collection, 1928

Homer Ransford Watson (Canadian, 1855-1936)

A Coming Storm in the Adirondacks, 1879

Oil on canvas, 33¾ x 46⅝ in.

The Montreal Museum of Fine Arts, Gift of George Hague

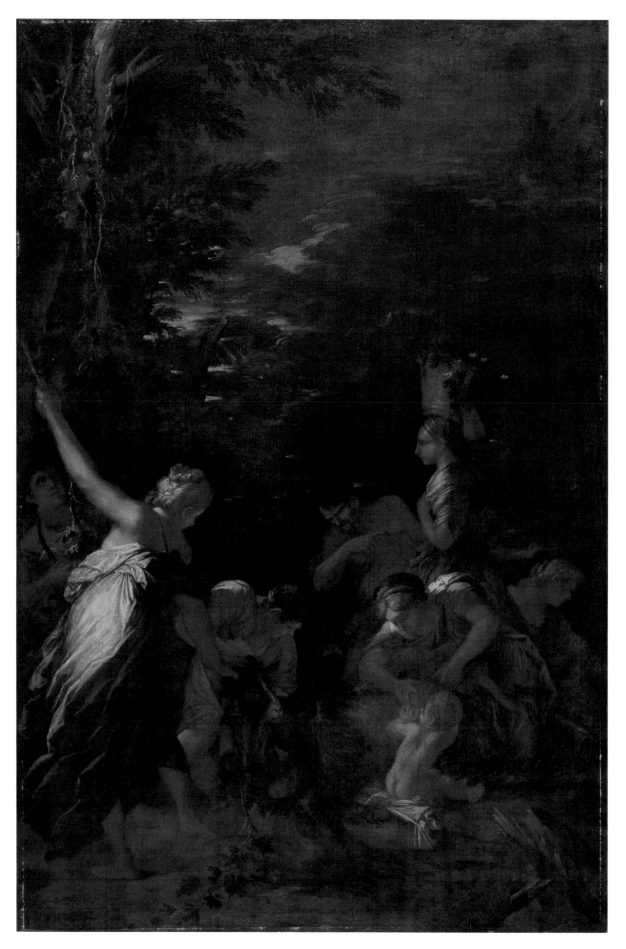

Salvator Rosa (Italian, 1615-1673)
The Nurture of Jupiter, ca. 1659
Oil on canvas, 78 ¹⁵⁄₁₆ x 52¾ in.
Davis Museum and Cultural Center, Gift of Dr. and Mrs. Arthur K. Solomon

A Search for the "Turneresque" in Nineteeth-Century Storm Painting

‿❧

HARDY S. GEORGE

The mountain and marine storm paintings by J.M.W. Turner (1775-1851) represent a high level of achievement in the development of this genre in Romantic art. Determining the nature and extent of Turner's legacy in this realm is problematical. On the other hand, it is not difficult to connect his storm paintings with earlier developments in seventeenth- and eighteenth-century art and the principles associated with the Picturesque and Sublime. The work of Claude Lorraine (1600-1682), Salvator Rosa (1615-1673), Claude-Joseph Vernet (1714-1789), Philippe-Jacques de Loutherbourg (1740-1812), Alexander Cozens (1717-1786), and John Robert Cozens (1752-1797) appeared to embody the principles set forth by the philosopher John Locke (1632-1704) and in the related essays on aesthetics by Joseph Addison (1672-1719), Edmund Burke (1729-1797), and Richard Payne Knight (1750-1824).[1]

Storm subjects in painting, particularly marine subjects, were brought to a high degree of excellence in seventeenth-century Dutch painting followed by similar developments in late eighteenth- and early nineteenth-century British painting. During the Romantic period Dutch art remained the model for all marine art and in particular subjects of storms at sea. Salvator Rosa's *The Nurture of Jupiter* (cat. 59; p. 46), Claude-Joseph Vernet's *The Storm* (cat. 73; p. 17) and Philippe-Jacques de Loutherbourg's *Landscape with Overturned Wagon in a Storm* (cat. 41; p. 48), help explain the tremendous power these artists exerted on the imaginations and works of the Romantics, and particularly on Turner's early paintings of storm swept Alpine scenery and fierce maritime gales. Early Romantic artists portrayed sea and land storms and concocted potent theatrical effects drawn at times from observation and experience, but most importantly from the study of the skillful creations of some of the past masters in the art of representing extreme weather conditions.

John Robert Cozens' sketches of the Alps, made en route to Rome in 1776, would influence Turner's portrayal of some of the same subject matter when he toured the Alps in 1802. Cozens wrote to the artist George Romney (1734-1802) outlining the different kinds of passions associated with landscape painting and Salvator Rosa's "infinite sublime," indicating the Italian artist "excelled all other painters in this kind of sublimity which may sometimes be produced in a landscape. A river winding between vast chains of mountains, such as we sometimes see in the works of Salvator Rosa, leads the mind beyond what the eye sees."[2] John Robert Cozens applied these principles in the dark and foreboding atmosphere created by the storm swept sky above the Alpine setting of *View of a Schloss between Bolzano and Trent* (fig. 10; p. 49).

It was Turner's pictorial treatment of the vastness of space that gives added meaning to the philosophical and scientific speculations of Addison concerning "those unfathomable depths of ether" that cannot "be seen by the strongest of our telescopes ... a labyrinth of suns and worlds, and confounded with the immensity and

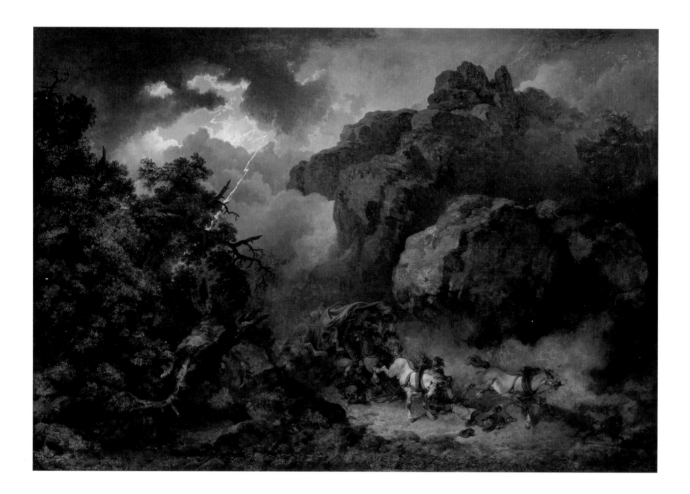

Philippe-Jacques de Loutherbourg (French, 1740-1812)
Landscape with Overturned Wagon in a Storm, 1809
Oil on canvas, 28¼ x 41½ in.
Mead Art Museum, Amherst College, Amherst, Massachusetts
Purchased in honor of Susan Dwight Bliss

magnificence of nature."[3] This aspect of the Sublime becomes more evident in Turner's late watercolor sketches and paintings (cats. 70, 71; pp. 52, 53) where the subject matter indicated by the titles becomes secondary to the overall composition made up of indivisible combinations of sky and water. The turmoil and oceanic greatness of these subjective works gives new meaning to the Romantic Sublime. With Turner's death and the emergence of various forms of Victorian and academic genre painting this aspect of his art did not experience further development.

Turner's true successors cannot be easily determined – especially the artists who further developed his methods and ideas in the portrayal of storm subjects. Clarkson Stanfield (1793-1867) and Augustus Wall Callcott (1779-1844) painted Dutch-like sea subjects in the manner of Turner's early maritime paintings. It is difficult to associate Turner with a clear line of development in the portrayal of landscape and maritime subjects, as can be done with John Constable (1776-1837) and the later developments of the French Barbizon School of landscape painting. Perhaps it could be said that Turner had few immediate European followers. Something of the magnificence and subjectivity of his late works re-emerge in Claude Monet's (1840-1926) paintings of the Houses of Parliament and Waterloo Bridge in London, which he painted during the winters of 1899, 1900, and 1901 at different times of day and under varied atmospheric conditions. He finished these works much later in his Paris studio. These are hardly storm paintings. These works, like Turner's late views of Venice, combine observation with an intense emotional response to the subject. Like James McNeill Whistler (1834-1903), however, Monet denied being influenced in any way by Turner's work.

Turner first documented his experiences of snowstorms in the Alps in a watercolor of 1820 titled *Snowstorm: Mont Cenis* and another of 1829 titled *Messieurs les voyageurs on their return from Italy (par la diligence) in a snow drift upon Mount Tarrar, 22nd January, 1829*. Both relate to his first two visits to Italy, at which times he unwisely

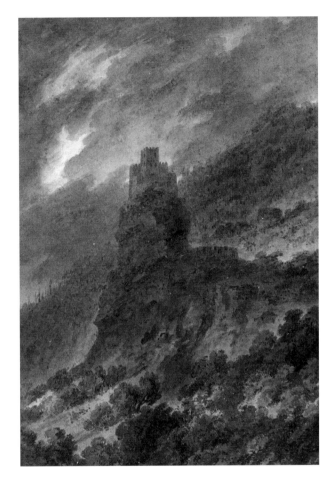

Fig. 10
John Robert Cozens (British, 1752-1797)
View of a Schloss between Bolzano and Trent. n.d.
Watercolor, 18 1/16 x 12 1/16 in.
Victoria & Albert Museum, London, UK /
The Bridgeman Art Library

J.M.W. Turner (British, 1775-1851)
Figures on a Beach, ca. 1840-1845
Oil on paper, 10⅜₆ x 11¾ in.
Tate Gallery, London / Art Resource, NY

J.M.W. Turner (British, 1775-1851)
Red Sky over a Beach, ca. 1840-1845
Oil on paper (unique), 11¹⁵⁄₁₆ x 18⅞ in.
Tate Gallery, London / Art Resource, NY

J.M.W. Turner (British, 1775-1851)
Ship in a Storm, ca. 1840-1845
Oil on board, 11⅞ x 18¾ in.
Tate Gallery, London / Art Resource, NY

J.M.W. Turner (British, 1775-1851)
Shore Scene with Waves and Breakwater, ca. 1835
Oil on board, 9 x 12 in.
Tate Gallery, London / Art Resource, NY

John F. Kensett (American, 1816-1872)
Passing Off of the Storm, 1872
Oil on canvas, 11⅜ x 24½ in.
The Metropolitan Museum of Art, Gift of Thomas Kensett, 1874

delayed his departure and was confronted by the difficulties of winter weather in crossing the Alps. It was not until much later that he exhibited his most dramatic paintings of snow storms and avalanches in the Alps. What is interesting was that Turner wished to emphasize his personal experience of the overturned diligence, as well as the actual time and place of the storm, when crossing the Alps on his return to England from Italy in January 1820. Here he stressed more of a sense of the ridiculous and less of the elevated sublimity that he had employed eight years earlier in his painting of *Snow Storm: Hannibal and His Army Crossing the Alps.* Turner's Alpine storms, rather than his storms at sea, appear to have had a greater impact on nineteenth-century American landscape painters, particularly Thomas Cole, John F. Kensett (1816-1872), and Thomas Moran (1837-1926).

In painting some of his earliest landscapes Cole made subtle rearrangements in the compositions, while making the general topography readily recognizable, and his work was appreciated for its truthfulness to nature. This use of dramatic subject matter with an underlying sense of arrangement is, of course, a characteristic Turner, Constable, and other early nineteenth-century English and European landscape painters were striving for. While Cole's paintings of the mountainous scenery of New York and New Hampshire seem related to Turner's early paintings of the mountains of Scotland, Wales, and the Alps, there is little to support a direct connection. Cole, as a young boy in Lancashire, England, might have received drawing lessons while a student in boarding school at Chester, but appears to have had little formal training when he became an engraver at a calico printing works in Chorley. By 1817, at age sixteen, Cole was working as an engraver's assistant in Liverpool. This was the year that Turner exhibited his *The Decline of the Carthaginian Empire* accompanied by the artist's ongoing poem titled *Fallacies of Hope* which refers to the gathering haze at sunset in the painting sending a "stormy signal" of catastrophic future events.

In 1819, after working as an engraver in Philadelphia, Thomas Cole joined his family in Steubenville, Ohio, where he studied oil painting under a little-known portrait painter named John Stein. Cole tried his hand as an itinerant portrait painter, painting historical and genre subjects as well as stage sets. By the fall of 1823 he was in Philadelphia where he made frequent visits to the Pennsylvania Academy of Fine Arts exhibition galleries. There he studied the landscape paintings of Thomas Birch (1779-1851) and Thomas Doughty (1793-1856), and most likely a mythological landscape thought to be by Salvator Rosa.[4] In furthering his development as a self-taught painter, Cole studied William Oram's book on *Precepts and Observations on the Art of Colouring in Landscape Painting* (London, 1910).[5] This book contains many of the ideas current in late eighteenth-century England concerning the use of ideal compositional arrangements in the portrayal of landscape; precepts associated with the idealized seventeenth-century Italian landscapes of Claude Lorraine, as well as those of Nicolas Poussin (1594-1665), Gaspard (Poussin) Dughet (1615-1675) and Domenichino (1581-1641). The painting techniques used by the seventeenth-century Dutch painters, Jan Both (1618-1652) and Aart van der Neer (1603-1677), were included as well. The illustrated manual also covered the depiction of various types of clouds, and the use of light and dark tonalities created by time of day and changing weather conditions. Furthermore, the related use of aerial perspective and color gradations was discussed. In the 1820s there was a growing nationalistic interest in American landscape subjects combined with an ever present religious fervor that helped foster a form of the Sublime in subjects that at times bordered on the evangelical. The portrayal of the storm, or approaching storm, in the works of Claude Lorraine and the Dutch painters, would have been central to the painting methods associated with the principles of the Sublime.

Thomas Cole painted the Catskills and the mountainous scenery of New Hampshire, Vermont, and northern

Thomas S. Moran (American, 1837-1926)
Mountain Valley, ca. 1865
Oil on canvas, 39¼ x 56¼ in.
The Philbrook Museum of Art, Tulsa, Oklahoma, Museum Purchase

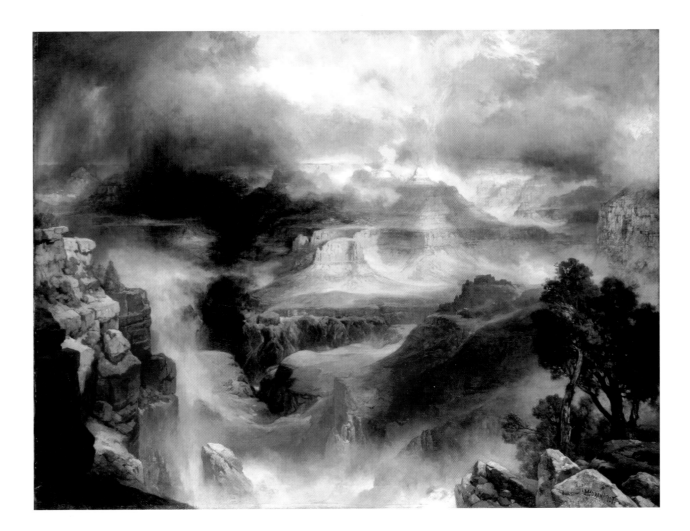

Thomas S. Moran (American, 1837-1926)

Grand Canyon, 1907

Oil on canvas, 30¼ x 40¼ in.

The Philbrook Museum of Art, Tulsa, Oklahoma, Gift of Laura A. Clubb

New York. Moran depicted the dramatic scenery of the Far West after the Civil War (cat. 52; p. 56) and some stormy sea views along the Long Island coast. For both these artists, Turner's methods of portraying mountain scenes and marine subjects were sources of inspiration. While Turner is referred to as an influential source for Cole and Moran, the exact nature and extent of the English artist's influence is difficult to determine. Cole, who is associated with establishing the Hudson River School of American landscape painting in the 1820s, seems to have developed his talent for this particular genre independently, as an autodidact. His first teacher was an itinerant portrait painter. He later became interested in the landscape paintings of Joshua Shaw (1777-1860), Alvan Fisher (1792-1863) and Thomas Doughty. These early American landscape painters were moderately successful in their portrayal of the picturesque scenery of the northeastern United States. Washington Allston (1779-1843), a history painter who received his training in London, introduced ideas associated with the then current concepts of the Sublime and in 1804 painted *Rising of a Thunderstorm at Sea* (Museum of Fine Arts, Boston).

Cole sailed for London in June 1829 after an exhibition of his painting of *The Subsiding of the Waters of the Deluge*. Upon his arrival he took lodgings at number 11 London Street and then 4 Grafton Street, near Fitzroy Square and the area associated with artist's residences and studios. Charles Robert Leslie (1794-1859), a fellow American and later biographer of John Constable, introduced Cole to a number of artists and to Constable, who was by then a well-known painter living close by at 35 Charlotte Street, Fitzroy Square. Turner, who had returned in January from an extended stay in Rome, had a studio, residence, and his own private art gallery to exhibit his works, on Queen Ann Street, within walking distance of Fitzroy Square. In London, Cole completed a number of paintings of American subjects, some with threatening cloud effects, among them the *Falls of Niagara* and *Tornado Passing American Forest*.

In 1830 he exhibited his North American landscapes at the British Institution and the Royal Academy. A version of *Falls of Niagara* (unlocated), measuring 5′ 9″ by 7′, was exhibited at the British Institution in February 1830. A tornado painting was exhibited in 1831 at the British Society of Artists. This work was well received by the critics. Cole paid tribute to Lord Byron in a painting of *Newstead Abbey at Sunrise*, the Nottinghamshire family home of the famous English poet. The dark, stormy, and rather spooky effect in the brown-wash over pencil sketch of *Newstead Abbey* appears related to Constable's somber sepia-wash technique of around 1830.

Turner's *The Decline of the Carthaginian Empire* (fig. 11) and *Snow Storm: Hannibal and His Army Crossing the Alps* (fig. 12) were probably the two works that had the greatest impact on Cole while on his first visit to London (1829-31). The *Hannibal* painting would have been appreciated as a subject of the titanic struggle between Rome and Carthage made familiar in English schools by the Latin accounts of the Punic Wars. Turner made reference to the stormy conditions that Hannibal's invading army supposedly encountered in crossing the Alps in another passage of *Fallacies of Hope* accompanying the picture. Hannibal's defeat was not only due to the inclement weather and mountainous terrain of northern Italy, as shown in the painting, but also attributed to the failure of establishing supply lines from Carthage. Hannibal's defeat led to Carthage surrendering its Spanish province to Rome and spelt the end of the Carthaginian commercial prowess. The painting, exhibited three years before Napoleon's decisive defeat at the Battle of Waterloo in June 1815, was also understood as an indirect reference to Napoleon's invasion of northern Italy in 1796. As well, the year the work was shown marked the invasion of Russia by Napoleon's *Grande Armée* of 500,000 troops.

In London Cole met Constable, Turner, and the portrait painter Sir Thomas Lawrence (1769-1830). Turner had returned to London in February from a six months stay in Rome where he completed three paintings and arranged

an exhibition at the Palazzo Trulli. He planned to return to Rome that spring or summer. In May 1829 he exhibited *Ulysses deriding Polyphemus – Homer's Odyssey* (fig. 13), of which Cole made sketches, at the Royal Academy.[6] In June and July Charles Heath arranged an exhibition of Turner's thirty-six *England and Wales* watercolors at the Egyptian Hall, Piccadilly.

In late September Turner's father died; his trusted companion and factotum, who managed his son's affairs and helped prepare and stretch canvases and varnish the pictures when completed. At that point Turner was "truly alone in the world."[7] It is not surprising to find that nine days later, on 30 September, with an increased sense of his own mortality, Turner wrote his first will, leaving *Dido Building Carthage* (exh. R.A. 1815) and the *The Decline of the Carthaginian Empire* to the National Gallery. Walter Thornbury, Turner's early biographer, was told that: "Turner never appeared the same man after his father's death; his family was broken up."[8] This is the person Cole would have met on 12 December when the young American artist visited Turner's private gallery. Here Cole saw Turner's *Dido Building Carthage* and the *The Decline of the Carthaginian Empire*. He referred to the former as a "splendid" and "poetic" painting which "very much resembles some of Claude's [harbor paintings]."[9] These paintings would have had a greater influence on the development of his work than the radical departure found in Turner's *Ulysses deriding Polyphemus* with its bright, high keyed colors and summary, sketch-like technique. Turner, after all, had recently stipulated in his will that the two Carthage paintings should be "placed by the side of Claude's *Sea Port* and *Mill*" hanging in the temporary quarters of the national collection soon to be moved from its location at 100 Pall Mall, to the planned National Gallery on Trafalgar Square.[10] More importantly, in Turner's studio Cole must have seen *Snow Storm: Hannibal and His Army Crossing the Alps* with its maximum dramatic effects created by the whirling motion of the storm clouds which arch past the sun and

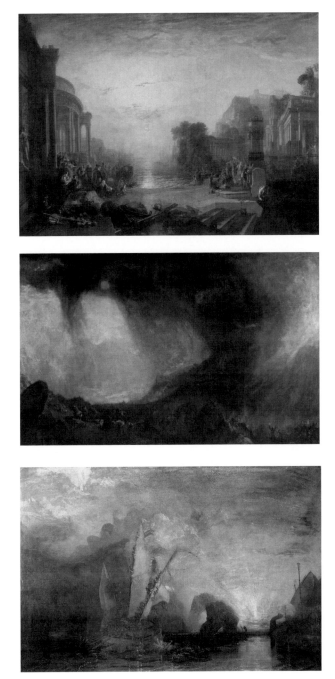

Fig. 11
J.M.W. Turner (British, 1775-1851)
The Decline of the Carthaginian Empire, exh. 1817
Oil on canvas, 67 x 94 in.
Clore Collection, Tate Gallery, London / Art Resource, NY

Fig. 12
J.M.W. Turner (British, 1775-1851)
Snow Storm: Hannibal and His Army Crossing the Alps, exh. 1812
Oil on canvas, 57½ x 93½ in.
Clore Collection, Tate Gallery, London / Art Resource, NY

Fig. 13
J.M.W. Turner (British, 1775-1851)
Ulysses deriding Polyphemus – Homer's Odyssey, exh. 1829
Oil on canvas, 52¼ x 80 in.
The National Gallery, London, UK / Bridgeman Art Library

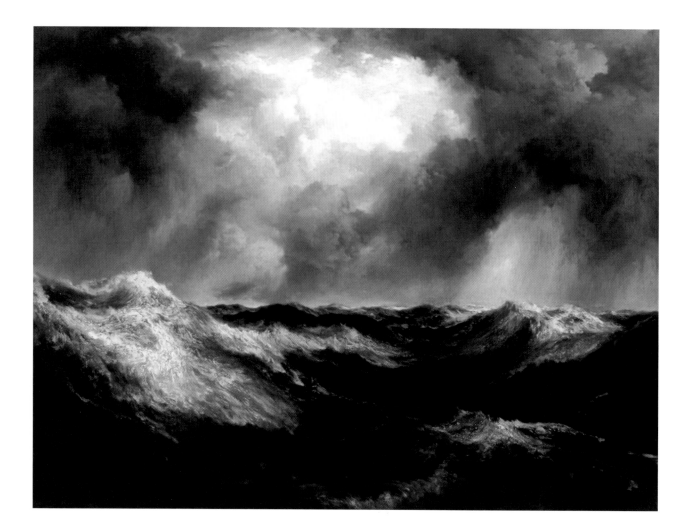

Thomas S. Moran (American, 1837-1926)

An Angry Sea, ca. 1897

Oil on canvas, 30¼ x 40⅛ in.

The Philbrook Museum of Art, Tulsa, Oklahoma, Gift of Laura A. Clubb

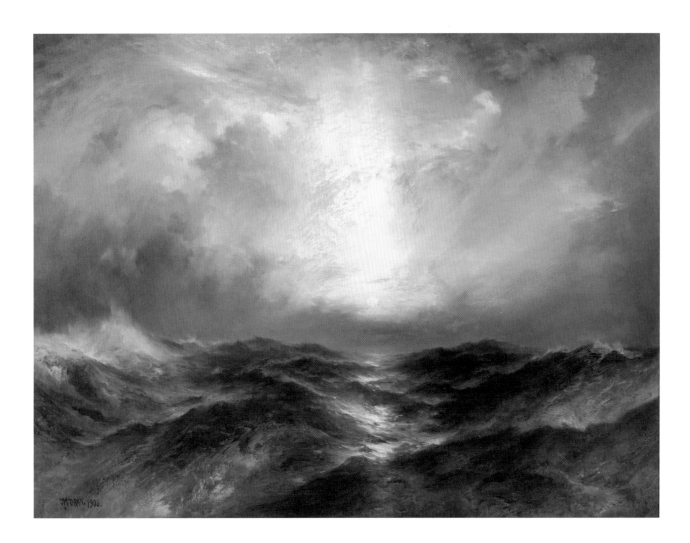

Thomas S. Moran (American, 1837-1926)

Sunset at Sea, 1906

Oil on canvas, 30 ³⁄₁₆ x 40 ³⁄₁₆ in.

Brooklyn Museum, Gift of the executors of the estate of Colonel Michael Friedsam

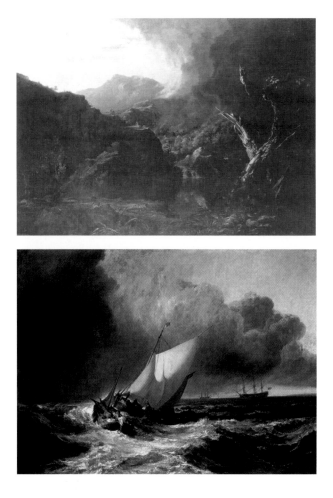

down into a brightly illuminated part of the sky. Cole had used similar combinations of storm clouds sweeping down over mountainous terrain with open passages of clear sky in his *Landscape* (fig. 14), and *Gelyna (View Near Fort Ticonderoga)* (cat. 13; p. 64), and later he would employ these effects in a painting completed in London of *Distant View of Niagara Falls* (1830, The Art Institute of Chicago).[11] Perhaps following the advice of Turner, Cole studied drawings by Claude Lorraine in the British Museum collection. Because of the French Revolution of 1830, and the threat of a cholera epidemic in Europe, he canceled his planned visit to France. In 1831, he again exhibited at the British Institution and the Royal Academy.

Cole visited the Duke of Bridgewater's collection of Old Master paintings in May 1830. The Third Duke of Bridgewater had acquired the Orleans collection in the chaotic aftermath of the French Revolution, and shortly after, in 1800, had commissioned Turner to paint a pendant for Willem van de Velde the Younger's (1633-1707) *A Rising Gale* (Toledo Museum of Art). In the Bridgewater collection Cole marveled at Van de Velde's *A Rising Gale*, and found Turner's companion to the *Bridgewater Seapiece* (fig. 15) to be "much grander," and thought "it the finest Sea piece" he had ever seen.[12] Cole also admired Aelbert Cuyp's (1620-1691) *The Embarkation of the prince of orange*, Claude Lorraine's *View of the "Sun setting on the sea with a solitary figure" (Ezekiel Mourning over the Ruins of Tyre)*, and *"Moses and the Burning Bush."*

In 1829, Turner exhibited his watercolor of *Messieurs les voyageurs on their return from Italy (par la diligence) in a snow drift upon Mount Tarrar, 22nd January, 1829*, dramatizing the accident he experienced on his return from Italy that year. Turner also exhibited his oil painting of *Ulysses deriding Polyphemus – Homer's Odyssey*, with a rocky coast line that might have been loosely based on pencil sketches made in the vicinity of Naples. Although this work is largely a product of his imagination, perhaps it was stimulated by

Fig. 14
Thomas Cole (American, 1801-1848)
Landscape, 1828
Oil on canvas, 26½ x 32½ in.
Museum of Art, Rhode Island School of Design
Walter H. Kimball Fund

Fig. 15
Joseph Mallord William Turner (British, 1775-1851)
Dutch Boats in a Gale: Fishermen endeavouring to put their Fish on Board (Bridgewater Seapiece), exh. 1801
Oil on canvas, 64 x 87½ in.
National Gallery, London

Edward Moran (American, 1829-1901)

Shipwreck, 1862

Oil on canvas, 30 x 40 in.

Munson-Williams-Proctor Arts Institute, Museum of Art, Utica, New York

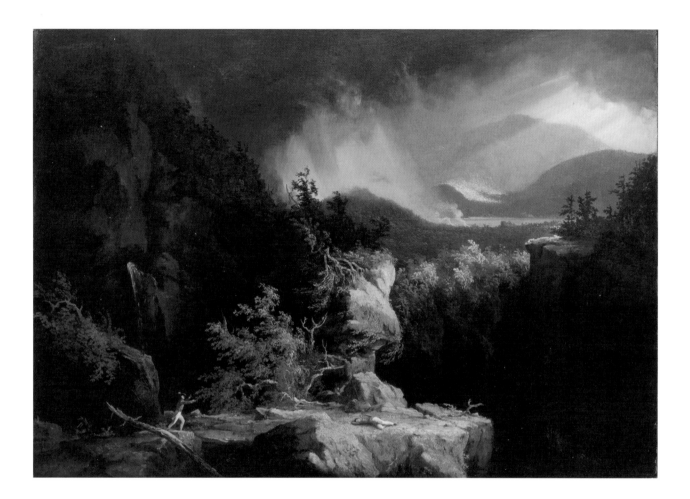

Thomas Cole (American, 1801-1848)
Gelyna (View Near Fort Ticonderoga), 1926-1929
Oil on panel, 24 x 34½ in.
Fort Ticonderoga Museum

Alexander Pope's translation of Homer's *Iliad* and *Odyssey*.

During his visit to London Cole was able not only to familiarize himself with paintings of Turner, John Martin (1789-1854), and other contemporary English landscape painters, as well as earlier French and Italian masters such as Claude Lorrain, Gaspard Dughet, Nicholas Poussin, and Salvator Rosa, whose works formed the background of late eighteenth and early nineteenth-century landscape painting. In London he also made extensive notations in one of his sketchbooks summarizing his plan for a series of monumental paintings recording the rise and decline of an ancient empire. The first painting would show the primitive and savage beginnings. The second painting would depict a "partially cultivated country." The third would display the growth of "a gorgeous City with piles of magnificent Architecture," and the fourth the destruction of the city by fire and "a stormy battle." The fifth painting would show the overgrown ruins of the city with its "dilapidated temples" and the "encroachment of the sea." This series of paintings was later realized after his return to New York, as *The Course of Empire* (1834-1836, New York Historical Society). The plans for this series indicate an awareness of current ideas about the life cycle of past empires: ancient Rome and Carthage. The decline of the greatness and power of these empires was supposedly brought about by an over abundance of wealth and luxury and similar cause and effect suppositions drawn from even more fantastic and legendary accounts. Cole, while residing first in Philadelphia and then in New York, may have seen Old Testament subjects of the destruction of ancient Babylon and the Biblical cities of Sodom and Gomorrah in the engravings of John Martin, whose mezzotint of *The Deluge* appeared in 1828 showing a crowd of struggling survivors trying to escape the rising flood waters and the huge approaching tidal wave (cat. 44; p. 13).

No doubt the example of Turner's recent residence in Rome, and the kind of encouragement Thomas Lawrence would have offered Cole, kept alive the importance of a period of study in the ancient capital of the arts. In May 1831, Cole traveled to Paris where he visited the Louvre, and then moved on to Italy, arriving in Florence in June and then in Rome, where he rented a studio and took classes, drawing from the model at the Academy of St. Luke. After almost a year in Rome, Cole returned to New York in 1832 and organized an exhibition of the paintings completed while in Italy. Cole returned to New York in January 1832 and, in 1833, was commissioned by Luman Reed to paint a series of five paintings (later titled *The Course of Empire*). He exhibited these works in 1836.

Cole's title for *The Course of Empire* is taken from a passage ("Westward the Course of Empire takes its Way") in Bishop George Berkeley's (1685-1763) publication of "Verses on the Prospect of Planting Arts and Learning in America" (1726). Another source of inspiration would have been Edward Gibbon's (1737-1794) widely acclaimed publication of *The Decline and Fall of the Roman Empire* (1776-1788). Constantinople, made the capital of the Roman Empire by Constantine (A.D. 330), flourished during the Byzantine Golden Age. The passage in Gibbon's book which captured the Romantic imagination was the vivid account of the final collapse and destruction of the capital city in 1453. Byron's reflections on "Wealth, vice, corruption" as the causes of the fall of ancient Rome, and the Venetian Republic in *Child Harold's Pilgrimage* (1812-1818) was also an influential and well-known literary source for Cole and other Romantic artists.

In order to emphasize the savagery of man's early existence, Cole, in his first painting in *The Course of Empire* series, titled *The Savage State*, includes threatening storm clouds that sweep down on the right side of the composition. A hunter holding a bow pursues a deer in the left foreground. In sequence, this painting is followed by a serene landscape composition titled *The Pastoral or Arcadian State*, and another of an orderly and prosperous city under a clear and tranquil sky. The third and fourth paintings are of *The Consummation of Empire*, and *Destruction*. In Cole's painting

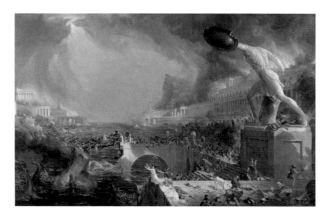

of *Destruction* (fig. 16), the storm clouds form a vortex as in Turner's earlier painting of *Snow Storm: Hannibal and His Army Crossing the Alps*. Here we have the benefit of Cole's own description of chaos enhanced by the storm raging in the middle distance: "Luxury has weakened and debased [the Empire]. A savage enemy has entered the city. A fierce tempest is raging. Walls and colonnades have been thrown down. Temples and palaces are burning." Andrew Wilton identifies "John Martin's dramatic mezzotint, *The Fall of Babylon* (1831), ... [as] the genealogy of Cole's image, " as well as "Robert Burford's panorama of *Pandemonium, from Milton's Paradise Lost*, shown in London during Cole's visit [there] in 1829."[13]

In 1839 Cole signed a contract with Samuel Ward, a wealthy banker and philanthropist, to paint the *Voyage of Life* series of paintings (figs. 17-19) in which, like *The Course of Empire*, the various stages of human existence are traced from the optimism of a dreamy "childhood" and the confidence of "youth" through the storms of "manhood" and the decrepitude of "old age" with its dark storm clouds revealing a heavenly light to the aged pilgrim in the last years of his metaphysical journey (cat. 15; p. 68).

When Cole returned to London in 1841, the pronounced changes in Turner's working method, signaled in his 1829 painting of *Ulysses deriding Polyphemus*, were now even more evident in the exhibited storm paintings of *Snow Storm, Avalanche and Inundation in the Alps* and *Blue Lights (close at hand) to warn Steamboats of shoal water*. In contrast to his paintings of an Alpine snow storm and a treacherous sea storm at the British Institution, Turner also exhibited three other paintings, of the placid waters of the Venetian Basin of St. Mark and the mouth of the Grand Canal reflecting the splendid architecture of *La Serenissima*. This dream-like rendition of Venice did not appear to attract the attention of Cole, but was taken up later by Whistler, Auguste Renoir (1841-1919), Monet, and Thomas Moran.

Cole's death in 1848, like Turner's in 1851, marked the closing of the Romantic era. The post-Romantic storm

Fig. 16
Thomas Cole (American, 1801-1848)
The Course of the Empire: Destruction, 1836
Oil on canvas, 39¼ x 63½ in.
© New-York Historical Society, New York / The Bridgeman Art Library

paintings that followed have a different emphasis. The dispassionate observations of calmer weather conditions are recorded in a less dramatic subject matter. The not so spectacular themes associated with the developments of realism and impressionism signaled the end of Romanticism, although certainly there are traditional Romantic elements in the stormy coastal paintings of Gustave Courbet (1819-1877), Louis-Gabriel Eugène Isabey (1803-1886) and Whistler. In 1854, when Courbet painted himself saluting the sea and several seascapes in and near Palavas on the Mediterranean, he expressed his Romantic sentiments in a letter to Jules Vallés: "The sea's voice is tremendous, but not loud enough to drown the voice of Fame, crying my name to the entire world."[14] In August 1867, while residing in Paris, Courbet visited a friend at Saint-Aubin-sur-Mer, a small seaside resort about twenty miles from Trouville. There he painted a *Waterspout* along with two views of the beach. In August 1869, Courbet was in Etretat, a small seaside town frequented by Louis-Gabriel Eugène Isabey, whose marine storms are among the most disturbing of their kind (cat. 38; p. 6). In 1870, Courbet wrote to his friend, the critic Jules-Antoine Castagnary (1830-1888), that he had been in Etretat, and during twenty days had painted nine seascapes. Of these paintings Jack Lindsay (1900-1990) considered *La Vague*, "especially successful with its fine depth of colour and its effect of the tremendous force and weight of water. Here, in his different way, he is close to Turner – not the Impressionists with their stress on momentary appearances of a liquid element."[15] *The Wave* (or *Stormy Sea*) along with *Etretat Cliffs* were sent to the Salon. In December 1869 Max Buchon (1818-1869), Courbet's "old friend," also from the Franche-Comté and a follower of the French social theorist Pierre Joseph Prudhon (1809-1865), died in the artist's arms of "blood-poisoning due to typhoid fever." Jack Lindsay thought the "ominous hues and crashing onslaught of the billow of *The Wave* [Courbet] was packing his own sense of inner and outer crisis."[16]

If the onslaught of the crashing waves in Courbet's painting is of the *Beach at Dieppe*, also titled *La Vague* (*The*

Fig. 17
Thomas Cole (American, 1801-1848)
Voyage of Life: Childhood, 1839-1840
Oil on canvas, 52 x 78 in.
Munson-Williams-Proctor Arts Institute, Museum of Art, Utica New York

Fig. 18
Thomas Cole (American, 1801-1848)
Voyage of Life: Youth, 1840
Oil on canvas, 52½ x 78½ in.
Munson-Williams-Proctor Arts Institute, Museum of Art, Utica New York

Fig. 19
Thomas Cole (American, 1801-1848)
Voyage of Life: Manhood, 1840
Oil on canvas, 52 x 78 in.
Munson-Williams-Proctor Arts Institute, Museum of Art, Utica New York

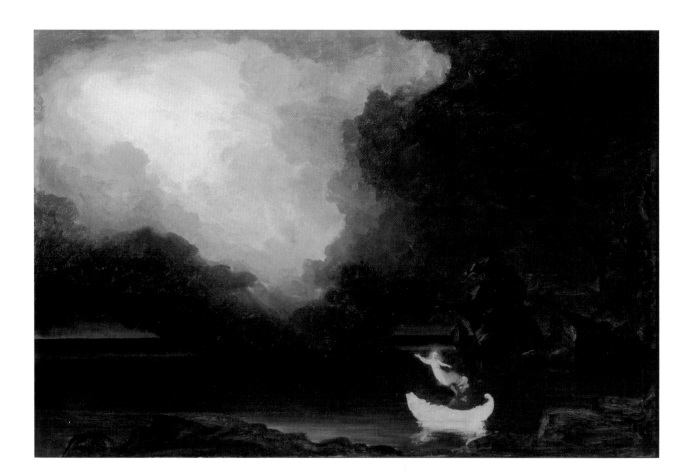

Thomas Cole (American, 1801-1848)
Voyage of Life: Old Age, 1840
Oil on canvas, 25 x 37 in.
Collection Neuberger Museum of Art, Purchase College,
State University of New York, Gift of Roy R. Neuberger

Wave) (cat. 19; p. 71), it may have other intense associations. Earlier, in September 1852, Champfleury (1821-1889) wrote to Max Buchon, in exile at Berne, that he had seen "Courbet, who was about to go to Dieppe for a few days." The purpose of this trip may have been to see his ex-mistress and their son. In July 1854, Champfleury again wrote to Buchon: "The truth is that this son, whom I have seen and who bore little resemblance to his father [Courbet], was a carver of ivory at Dieppe and had never followed any other profession. He died there before he was twenty years old."[17] Earlier, when Champfleury had written to Courbet in Ornans that his mistress had left Paris with their son, the artist replied: "May life be kind to her since she thinks she is making the right decision, I shall miss my little boy very much, but art gives me enough to do without burdening myself with a household; moreover, to my mind a married man is a reactionary."[18]

In painting the *Beach at Dieppe*, like other landscapes and seascapes of this general period, *Les bords de la mer à Palavas* (1854) and *Gorge dan une Forêt* [*le Puit Noir*] (ca. 1865, Oklahoma City Museum of Art), Courbet employed a mixed technique of brush and palette knife, giving his work a varied surface texture unlike the smooth surfaces associated with the glazing techniques of his academic contemporaries. Eugène Isabey, like other French Romantic landscape painters, developed a style based on the accomplishments of the British watercolor and oil painters such as Richard Parkes Bonington (1802-1828), Anthony Vandyke Copley Fielding (1789-1855), Constable, and Turner. Dutch seventeenth-century marine art had a greater impact on English art, as can be seen in the storms at sea by Dominic Serres (cat. 61; p. 87), Turner, Clarkson Stanfield (cat. 65; p. 16), and Augustus Wall Callcott. In England, a country surrounded by the sea, where, as in the Netherlands, maritime trade had brought ever increasing prosperity, there was a natural understanding and appreciation for the Dutch marine art.

France's wealth did not depend on extensive maritime trade. The dangers of shipwreck and the related terror of the Sublime can be seen in Théodore Géricault's *The Raft of the* Medusa (fig. 5; p. 29), but there is more of Michelangelo (1475-1564) and Peter Paul Rubens (1577-1640) in the monumental writhing and twisting bodies of the suffering survivors of the *Medusa* than anything produced by Willem van de Velde the Younger, where all the emphasis is placed on the fate of the ship in gale force winds and high seas. Eugène Delacroix's more reassuring subject of *Christ Asleep during the Tempest* (cat. 22; p. 10) is close to the Dutch tradition of ships caught in storms at sea. Here the fragile craft, with a frightened crew on a turbulent sea, combines a sense of drama and realism with a passage from the Bible that would be readily understood. While Courbet and Isabey shared Delacroix's Romantic vision in their portrayal of angry seas along the coast near Etretat, the early impressionists, such as Johan Barthold Jongkind (1819-1891), who painted with Isabey and Eugène Boudin (1824-1898) (cat. 3; p. 70) along the Channel coast were less interested in the allegorical drama of the storm. They displayed a more objective interest in the kind of benign weather conditions that tourists from Paris preferred. By the mid-1860s the Romantic tradition of sea painting was declining. This had a great deal to do with the changing taste and social habits of the urban middle class, as artists gave attention to a different type of marine and landscape subject. They painted city types enjoying the seaside and sunny landscapes, in the favored seasons – spring, summer, and autumn. Middle-class Parisians enjoying leisure time were depicted a number of times by Boudin and later by Claude Monet. In the 1860s Monet, who worked with Courbet at Trouville and was influenced by the atmospheric seashores and landscapes of both Jongkind and Boudin, portrayed the same general subjects and towns along the Channel coast, Deauville, Trouville, and Etretat, the picturesque places made easily accessible by the newly developed railways.

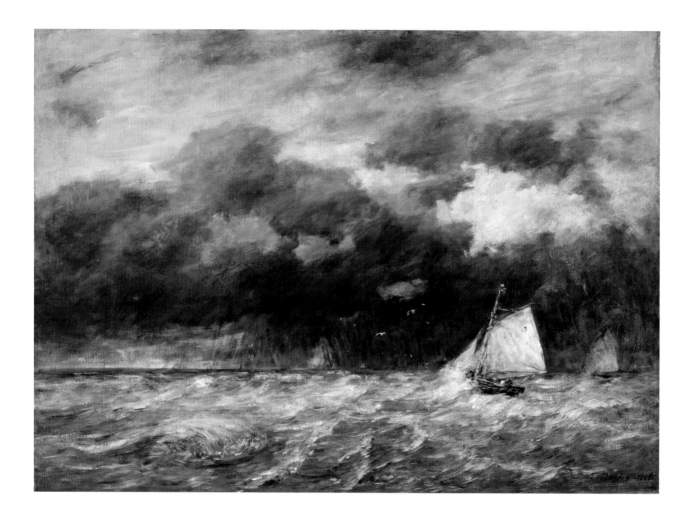

Eugène Boudin (French, 1824-1898)

A Squall, 1885

Oil on canvas, 25¹¹⁄₁₆ x 33⅝ in.

The Montreal Museum of Fine Arts, Dr. Francis J. Shepherd Bequest

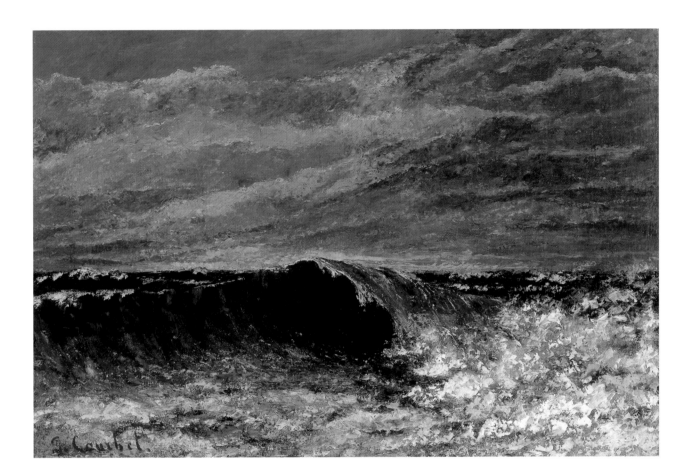

Gustave Courbet (French, 1819-1877)
Beach at Dieppe, 1865-1870
Oil on canvas, 24 x 36 in.
Collection of the Phoenix Art Museum, Gift of Mr. & Mrs. Arthur Murray

Of all the late nineteenth-century artists whose work can be associated with Turner's land and sea storms, Thomas Moran is perhaps the strongest adherent of what he understood to be, or at least what his critics understood to be, the "Turneresque." In the spring of 1861, Thomas and his older brother, Edward Moran, set sail from Philadelphia for Liverpool, England. Edward was also a seasoned seascape painter (cat. 47; p. 63) and an admirer of Turner. Like Thomas Cole, both the Morans were largely self-taught and familiar with Turner's work through engravings in books on travel and poetry, as well as the prints of his works in *Liber Studiorum*, and most likely his engravings in the *Ports of England, Southern Coast*, and *The Rivers of England*. The Morans would have also had the benefit of John Ruskin's *Modern Painters*, largely a defense and interpretation of Turner's work, of which the first volume appeared in 1843 and the last in 1860.[19] Like Cole, however, Thomas and Edward were probably not prepared for the actual color and appearance of Turner's paintings. James Hamilton (1819-1873), a painter of landscape and sea subjects (cat. 27; p. 32), knew Turner's works through printed sources, and had encouraged both the brothers in the early 1850s with helpful criticism. Hamilton expressed admiration for the seascapes of Turner as well as those of Clarkson Stanfield. Possibly the Morans had seen a couple of examples of Turner's work in a traveling exhibition of British art in Philadelphia in 1857-1858.

After Thomas and Edward arrived at Liverpool, they paid a visit to their birthplace, Bolden, a textile mill town near Manchester. From there they traveled south to London and its environs, making sketches of picturesque topography associated with Turner, in particular Margate, Ramsgate, and along the coast to *Sandown Castle*. They then traveled on to Deal, Dover, and Hastings. Thomas sketched the *Cliffs of Ecclesborn, Near Hastings* and *East Cliff* overlooking the Channel, where the main harbor had been destroyed during the violent storm that wrecked ships and played havoc with the Spanish Armada during the reign of Queen Elizabeth I (1533-1603). Thomas also sketched *On the Beach, Hastings* as well as *Carisbrooke Castle, Isle of Wight*. It is not surprising to find that the brothers sought out the places associated with prints they knew of Turner's work on the coasts of Sussex and Kent. Turner died ten years earlier, in 1851, and following this his works were exhibited at the National Gallery on Trafalgar Square. There Thomas sketched and possibly made his copy in oil of Turner's painting of *Ulysses deriding Polyphemus*, shown in a later photograph hanging over the fireplace in his East Hampton studio (photograph in East Hampton Library). Thomas Moran's painting titled *"Fiercely the red sun descending/Burned his way along the heavens"* (fig. 20) is obviously based on the imagery and fiery colors of Turner's *Ulysses*, but the subject, unlike Turner's, is not from Homer. Moran's title comes from Henry Wadsworth Longfellow's (1807-1882) *The Song of Hiawatha*, Canto IX, and displays an increased theatrical sense of the Sublime in blazing yellow and red sunset with the build up of storm clouds above the rocky shoreline on the right side of the composition. Thomas Moran also made a copy, in London, or shortly after his return to Philadelphia, of Turner's later painting of *The Golden Bough* (exh. 1834).

In 1871, Thomas Moran accompanied the expedition of Dr. Ferdinand Vandiver Hayden (1829-87) to the Grand Canyon of the Yellowstone. On 11 July 1871, Moran wrote about photographing with William Henry Jackson (1843-1942) the expedition photographer and Jackson's assistant Dixon. Moran describes "an immense gorge in the Mountains bordered with great cliffs & peaks of limestone … forming splendid foreground material for pictures." When they started back for camp "clouds began to gather & a rain set in the Mts all around us but did not fall heavily on us." At that time he was only concerned with the possible inconvenience of a rainstorm. When he completed his large painting (7′ x 12′) of *The Grand Canyon of the Yellowstone* the sky was relatively clear, and only a thin mist could be seen rising vertically from the distant waterfall. Accord-

ing to Ruth Moran, Thomas was "stunned by the radiance which he had not imagined but which he, himself, [would find] literally glowing in the Yellowstone country later in his life."[20] In this quote Ruth Moran is also referring to the radiance of Thomas' important oil painting of *The Grand Canyon of the Yellowstone* (1872), bought by the Smithsonian Institution to celebrate the government expedition.

In 1873, Moran accompanied Major John Wesley Powell's (1834-1902) expedition to the Grand Canyon of the Colorado. In the spring of 1874 the artist completed *The Chasm of the Colorado* (fig. 21) in his Newark studio from sketches and photographs made on the Grand Canyon tour. This large work was painted as a companion piece to *The Grand Canyon of the Yellowstone* (also measuring 7´ x 12´). In June, the painting was exhibited at the Corcoran Gallery of Art, while its companion hung in the Capitol. Dark storm clouds with streaks and veils of rain can be seen over the mountains in the upper left part of the composition. The combination of a clear sky and dramatic rain clouds of this kind have "something of the old romantic conception harking back to Cole."[21] The critic writing for the *Atlantic Monthly* compared *The Chasm of the Colorado* (the Grand Canyon) with the earlier *Yellowstone* painting which "was equally awful and desolate ... but its terror was lessened by the beauty and variety of the color which nature veiled her work of change and destruction. Here [in *The Chasm of the Colorado* painting] we have no such charm. We are led into a region where the eye has hardly a resting-place, ... unless it be turned upward to the sky. For this serene heaven – serene except where in one portion it darkens with the wrath of thunder clouds and the stream of deluging rain – looks down upon the very pit of hell. Only Dante's words seem fit to describe this scene."[22] *Grand Canyon* (cat. 50; p. 57) and *Mountain Peaks* (cat. 51) are later and freer interpretations of these important subjects he had observed, sketched, and photographed on the expeditions of 1871 and 1873. In the late nineteenth and early twentieth century, like Turner, Thomas Moran would draw upon

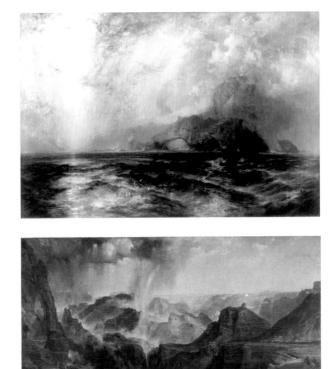

Fig. 20
Thomas S. Moran (American, 1837-1926)
"Fiercely the red sun descending/Burned his way along the heavens", 1875-1876
Oil on canvas, 33⅜ x 50¹⁄₁₆ in.
North Carolina Museum of Art, Purchased with funds from the
North Carolina Art Society (Robert F. Phifer Bequest)

Fig. 21
Thomas S. Moran (American, 1837-1926)
The Chasm of the Colorado, 1873-1874
Oil on canvas, 84⅜ x 144¾ in.
Smithsonian American Art Museum, Washington, D.C. / Art Resource, NY

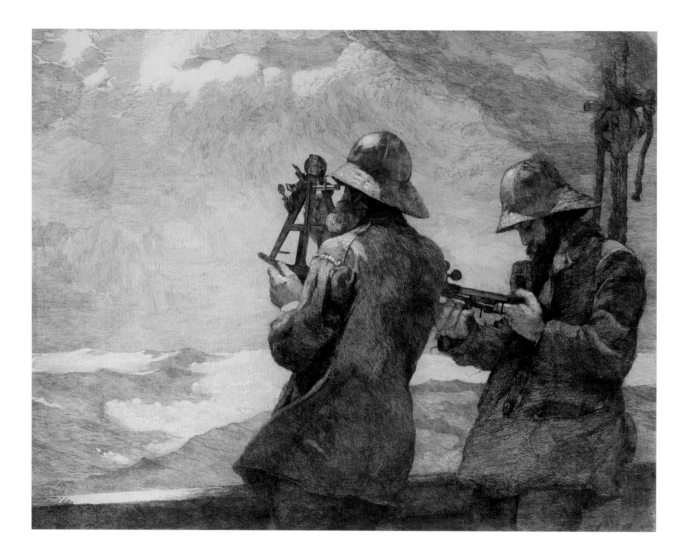

Winslow Homer (American, 1836-1910)
Eight Bells, 1887
Etching in black ink, 23⅞ x 29⅜ in.
Brooklyn Museum, Bequest of Anita Steckler

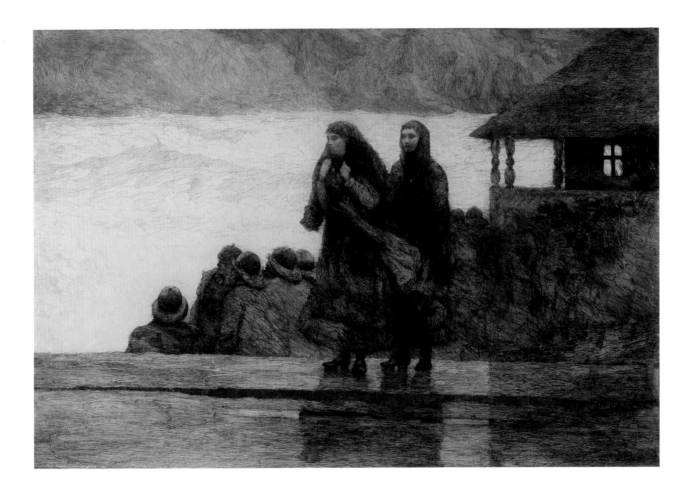

Winslow Homer (American, 1836-1910)
Perils of the Sea, 1888
Etching in black ink, 21⅟₁₆ x 28 in.
Brooklyn Museum, Carl H. de Silver Fund

sketches and source material gathered many years earlier to paint a more freely composed variant of a favored subject. The sweeping vistas of these works owe a great deal to the dramatic panorama landscapes of Frederic Edwin Church (1826-1900), Cole's student. This connection is even more pronounced in the monumental sea views of Thomas Moran's pictures of stormy seas and blowing gales along the eastern shoreline of Long Island in the 1880s and 1890s. Perhaps the stormy seascapes from the Brooklyn Museum (cat. 54; p. 61) and The Philbrook Museum of Art (cat. 48; p. 60) belong to this group of works Moran completed in his East Hampton studio. The artist continued to work as a full-blown Romantic, using sketches and his indelible memory to compose, in his studio, grand landscape and sea subjects with added storm effects to intensify the feeling of the Sublime. His late Romantic works were carried out sometime after the changes wrought by impressionism and post-impressionism, and during the period associated with the fragmentation of form introduced by Pablo Picasso (1881-1973) and the cubists. In Moran's "Colorado and Yellowstone immensities he reverted openly to the Turneresque"[23] and continued to nourish the bold spirit of Romanticism[24] even into the early years of the twentieth century.

Endnotes

[1]Locke, John. *Essay Concerning Human Understanding*, 1689; Joseph Addison's journal *The Spectator*, June & July 1712; Richard Payne Knight. *Analytical Inquiry into the Principles of Taste*, 1805.

[2]Clarke, Michael and Nicholas Penny, eds. *The Arrogant Connoisseur, Richard Payne Knight, 1751-1824*. Manchester: Whitworth Art Gallery, 1982: 96. See also Kim Sloan. *Alexander and John Robert Cozens The Poetry of Landscape*. New Haven and London: Yale University Press for the Art Gallery of Ontario, 1986: 113.

[3]*Spectator*, no. 420, 2 July 1712. Quoted in Andrew Wilton. *Turner and the Sublime*. London: British Museum Publications for The Art Gallery of Ontario, Toronto, The Yale Center for British Art New Haven, and The Trustees of the British Museum, London, 1980: 11.

[4]Wallach, Alan. "Thomas Cole Landscape and the Course of American Empire." In William H. Truettner and Alan Wallach, eds. *Thomas Cole Landscape into History*. New Haven and London: Yale University Press for the National Museum of American Art, Smithsonian Institution, Washington, D.C., 1994: 26; Dunlap, William. *History of the Rise and Progress of the Arts of Design in the Unites States*. Vol. 2. New York: Dover Publications, 1969: 359; Parry. "Thomas Cole's Early Career.": 160, 165-66.

[5]Ibid.: 28.

[6]For reproductions of Cole's pencil sketches (3½ x 6¼ in.), in the Detroit Institute of Arts, of Turner's *Ulysses deriding Polyphemus*, see Ellwood C. Parry III. *The Art of Thomas Cole Ambition and Imagination*. London and Toronto: University of Delaware Press, 1988: 97 (fig. 66).

[7]Finberg, A.J. *The Life of J.M.W. Turner, R.A.* Oxford: Clarendon Press, 1961: 318.

[8]Thornbury, Walter. *Life of J.M.W. Turner, R.A.* 2 vols. Hurst & Blackett, 1862: 319 (quoted in ibid.).

[9]Cole's 1829 notebook, pp. 14-15. Cole Papers, New York State Library, Albany. Quoted in Ellwood C. Parry III, op. cit.: 98. When Cole met Turner on this visit to the Queen Ann Street Studio and gallery, he expected "to see an older man with a countenance pale with thought," but he "was entirely mistaken…" there was nothing in his "appearance or conversation indicative of genius. He look[ed] like a seafaring man, a mate of a coasting vessel, and his manners were in accordance with his appearance." Cole could hardly "reconcile in his mind to the idea he painted those grand pictures. The exterior so belies its inhabitant the soul." Ibid.

[10]The National Gallery was built from 1833-1837.

[11]Related combinations of storm clouds can be seen in Cole's *View of Schroon Mountain, Essex County, New York, after a Storm* (1838), The Cleveland Museum of Art;

View from Mount Holyoke, Northampton, Massachusetts, after a Thunderstorm (The Oxbow) (1836), The Metropolitan Museum of Art, New York; *Catskill Mountain House: The Four Elements* (1843-1844), Alexander Gallery, New York.

[12]Thomas Cole's 1829 notebook, pp. 27-28, Cole Papers, New York State Library, Albany. Cited in Parry, op. cit.: 103.

[13]Wilton, Andrew and Tim Barringer. *American Sublime Landscape Painting in the United States 1820-1880.* Milbank and London: Princeton University Press, Tate Publishing, 2002: 105.

[14]Bowness, Alan; Marie Thérèse de Forges; and Michel Laclotte. *Gustave Courbet 1819-1877.* London and Paris: Arts Council of Great Britain and the Réunion des musées nationaux, 1978: 113.

[15]Lindsay, Jack. *Gustave Courbet His Life and Art.* Bath, Somerset: Adams & Dart, 1973: 237.

[16]Ibid.: 242.

[17]Courbet Documents. A collection of letters, notes, newspaper cuttings, and miscellaneous documents by or concerning Courbet, in the Salle des Estampes, Bibliothéque Nationale, Paris, box 3. Printed in Pierre Courthion, *Courbet raconté par lui-même et par ses amis,* vol 1: 110. Quoted in Gerstle Mack, Gustave Courbet. New York: Alfred A. Knopf, 1951: 86.

[18]Courbet to Champfleury, Ornans, undated. *Georges Riat, Gustave Courbet, peintre.* H. Floury, Paris; 1906: 94-5. Quoted in Mack, Ibid.

[19]Thurman Wilkins pointed out "no firm evidence indicates that Moran had read *Modern Painters* or at least much of it by this early date [ca. 1860]." He felt Moran had been exposed to "Ruskinian aesthetics through Ruskin's introductory text for Turner's *The Harbours of England.*" He thought that Moran was possibly encouraged to read Ruskin and study Turner's engraving by the artist James Hamilton. Wilkins with the help of Caroline Lawson Hinkley, with foreword by William H. Goetzmann. Norman: University of Oklahoma Press, 1998: 322 (endnote 8).

[20]Moran, Ruth B. "The Real Life of Thomas Moran." *American Magazine of Art,* 17, no. 12 (December 1926): 645. Quoted in Wilkins, op. cit.: 41.

[21]Sweet, Frederick A. *The Hudson River School and the Early American Landscape Tradition.* New York: Whitney Museum of American Art, 1945: 108.

[22]Cook, Clarence. *Atlantic Monthly,* 1874: 375. Quoted in Nancy Anderson. *Thomas Moran.* New Haven and Washington, D.C.: Yale University Press for the National Gallery of Art , 1997: 57.

[23]Barker, Virgil. *American Painting.* New York: The Macmillan Company, 1950: 588.

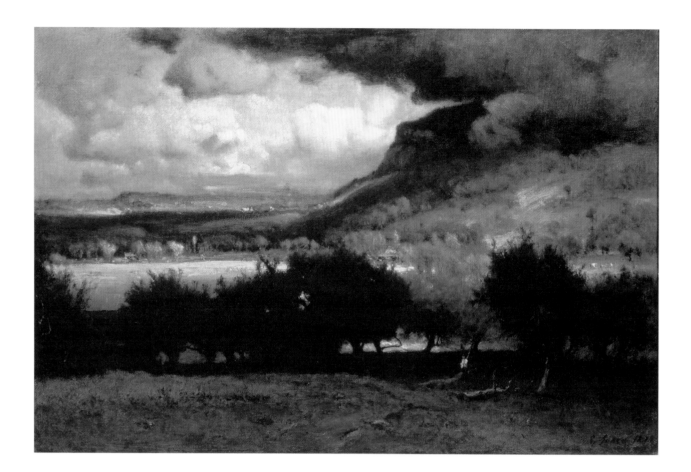

George Inness (American, 1825-1894)
The Coming Storm, 1878
Oil on canvas, 16 x 24 in.
Munson-Williams-Proctor Arts Institute,
Museum of Art, Utica, New York

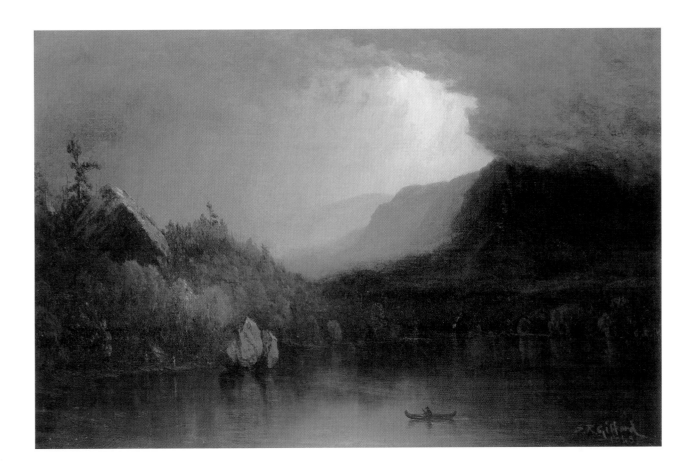

Sanford Robinson Gifford (American, 1823-1880)

Study of a Coming Storm on Lake George, 1863

Oil on canvas, 12 x 18 in.

The Butler Institute of American Art, Youngstown, Ohio,

Gift of Almira Wick

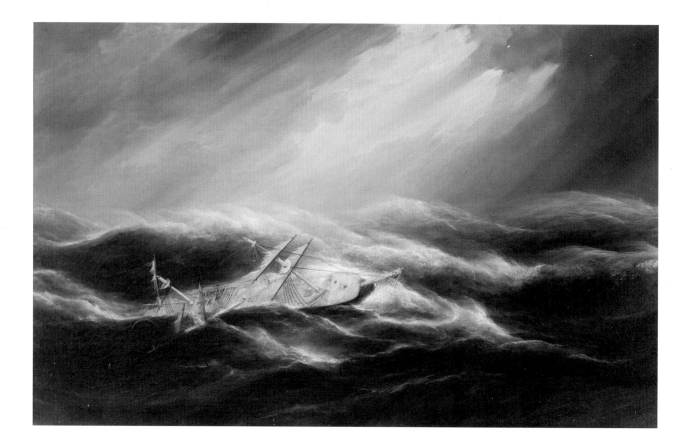

Samuel Walters (British, 1811-1882)

Houqua, 1848

Oil on canvas, 27¼ x 42¼ in.

Peabody Essex Museum, Salem, Massachusetts

Confronting the Tempest:
Observational Authority in Marine Painting

꒳

Daniel Finamore

Yes, as every one knows,

meditation and water are wedded for ever.

— Herman Melville, 1851[1]

As the most famous ship of the twentieth century took on water before it plunged to the frigid depths of the North Atlantic, crew and passengers raced about frantically, searching for loved ones, trying to save themselves and their possessions, or simply attempting to prepare to come to terms with imminent destruction. Amidst the tumult on the *Titanic* during her final minutes afloat, a well-dressed man was reported to have stood in the first-class smoking lounge, calmly contemplating a marine painting by the renowned British artist Norman Wilkinson, entitled *Approach to Plymouth Harbor*. Once Thomas Andrews, the designer of the ship, became aware that it would sink, he did what he could to assist passengers to the lifeboats. But in his final moments alive, he was seen staring at the painting, perhaps seeking solace in a scene in contrast to his own, in which the sea was a benign force.

The tradition of maritime painting frequently relies not solely upon an artist's choice of subject matter to evoke an emotional response. In many instances, the personal experience of the viewer enables a response based in an innate assessment of "authenticity." Is the subject depicted believable based on the viewer's personal experience or level of knowledge about it? That assessment has been based on divergent criteria over time, including whether the artist or viewer expected nautical veracity to be the ultimate goal,

or merely a tool for achieving higher purposes. Though it is doubtful that he was conscious of the reasons for his attraction to Wilkinson's work, Andrews may well have been drawn to the painting for reasons similar to those expressed by seventeen-year old Frederick Jordan Ranlett (1857-1924) who visited the Mechanic's Fair at Faneuil Hall in Boston in autumn of 1874. In the art gallery there he found a series of marine paintings that impressed him sufficiently to warrant several paragraphs in his diary. Although Ranlett was not a professional sailor he had an uncommon understanding of the sea, having circumnavigated the world in a ship commanded by his father before he had turned ten. A group of paintings in the exhibition by the Danish-American artist Johan (John Erik Christian) Peterson (1839-1874) made the most lasting impressions on him. *Ship on Fire* portrayed a vessel abandoned to a conflagration while another saved the crew who had taken to the lifeboats. The sails of the rescue ship were aglow with reflected light from the blaze, in striking contrast to the dark blue waves and smoky sky. The effect, he noted: "filled me with admiration."

Collision at Sea captured the scene moments after the fogbound impact of a sailing craft with a steamer. Ranlett was struck by the way "the apparent helplessness of the ship affects one as would an animal in pain." Another work struck him as "almost sublime," while a brig struggling to stay afloat off Cape Hatteras, a place noted for frequent storms, was "depicted in the most natural manner" by the spray blown from the crest of the wave. The credibility of these paintings derived from the depiction of mundane

detail amidst high drama, in a manner "that none but a sailor (amateur or otherwise) would have detected."[2]

Certainly, one need not be a sailor-artist to create marine works with adequate authenticity to win over the sailor-cognoscenti. But eighteenth-century enlightenment sensibilities greatly valued the authority gained from dispassionate observation and the accuracy and precision with which a practicing seafarer could transmit the critical factors of a situation. It was out of the enlightenment that both private commercial voyages based on the practical application of scientific knowledge and the demand for marine paintings treating these voyages as their subject arose.

Among the earliest surviving marine paintings of colonial America, the watercolor entitled *This shews the Schooner* Baltick *in distress in 6 fathoms of Water on Nantucket Sholes with every thing wash'd of the Deck & Two men drounded y,* 19th *of Dec.* (cat. 72; p. 83) depicts an event that is not documented beyond this painting. It is part of a set of three, the other two, *This shews the Schooner* Baltick *Coming out of St. Eustatia ye 16th of Nov, 1765* and *This Shews the Schooner* Baltick *on the Middle Ground going into Cape fare in a Very hard gale of Wind with the Pilot boat beating out to Her Feb,y 16th 1766,* (not in exhibition) portraying challenging but less dire circumstances.

Inasmuch as written accounts of disasters such as captivity by native Americans or pirates acted as methods of disseminating "official" versions of events that might otherwise be disputed, paintings like the presentation of the *Baltick* may have been created in part to be seen by owners or insurers of the ship, or even family of lost crew, with the goal of reassuring them that all proper procedures were followed, and that the disaster was an act of God and not the fault of men.

The small but vibrantly painted forty-five–ton schooner *Baltick*, built in Newbury, Massachusetts, in 1763, most likely would have carried fewer than ten crewmen for a coasting voyage to the Caribbean. No list of crew survives, nor does the name of the artist of these works, but it is no doubt intentional that they present the scenes as if they were observed directly by the artist, and were presented with the greatest accuracy possible. The disaster scene shows three of the crew in the water amid towering swells and a tangle of spars and rigging, frantically waving their arms in the air. The painting, which cannot be viewed in isolation from its bold narrative title which states that two crewmen were lost, strongly suggests that lifesaving measures were undertaken and that one mariner was actually rescued from the heavy seas.

Marblehead artist and mariner Ashley Bowen (1728-1813) portrayed another casualty of New England shoal waters in a watercolor triptych he entitled *Ship* Postillion (cat. 4; p. 84). Bowen spent many years at sea as a sailor and master, and later years as a rigger and painter of ships. Late in his life, he pointed to his time in the Gulf of St. Lawrence, surveying with James Cook as a highlight, but his lifetime of copious journals and watercolors prove him to have been greatly curious and though not a trained artist, a skilled one.[3] His unrefined watercolor presents a tripartite narrative of disaster that befell this large early American merchantman. Bowen dismisses the storm that begot the wreck, choosing to place all artistic focus on the predicament of the ship and crew. The text beneath is a dispassionate testimonial of the events that destroyed the vessel and seven men, including the master, as if this were to become a document for an inquest or court case, though there is no indication that it was. In fact, the papers on which the painting and text appear have been folded several times, into a size similar to what documents and business papers of the day were for filing purposes. Though perhaps created to provide a descriptive narrative of the tragic events, it also seems to have served in the role of momenti mori for the deceased sailors, with a suggestion of ex-voto for the survivors (though in a restrained, matter-of-fact, Protestant manner).

The first scene, entitled "No. 1 Represents the ship Postillion in her proper form, January 29th at 1 O'Clock

Unidentified Artist
This Shews the Schooner Baltick *in distress in 6 fathoms of Water on Nantucket*
Sholes with every thing wash'd of the Deck & Two men Drounded y, 19ᵗʰ of Dec., n.d.
Watercolor on paper, 13¼ x 18¼ in.
Peabody Essex Museum, Salem, Massachusetts

Ashley Bowen (American, 1728-1813)

Ship Postillion, n.d.

Watercolor on paper, 11½ x 15 in.

Peabody Essex Museum, Salem, Massachusetts

P.M." shows the full-rigged ship *Postillion* proceeding proudly with all sail set in a light breeze, and small black circles just above the rail to represent the crew on deck. The accompanying narrative provides details:

"Sunday, January 28th, 1781. This morning at 8 o'clock came on Board Mr Norton A Pilot for the Sholes, and we weighed Anchor at Homes's Hole in the Vineyard; the wind W.S.W. and came over the Sholes. Much wind all day; we were brest of Cape Cod at 12 at Night, and the wind vear'd W.N.W. and N.W. About noon the wind was at W.S.W. and in the afternoon wore to southward. 3 O'clock we saw [ship] Agamentacus Bearing (illegible). We stood in for the Land. Not thinking ourselves so nigh, which (deceiv'd?) us by the snow, that was on the land (illegible) Reeft all three Topsails."

The second panel shows the *Postillion* with hull severely heeling, completely dismasted and surrounded by rigging and jetsam in the water. Bowen has painted a choppy horizon, each wave a single stroke of his brush, with waves also extending up the sides of the hull. But the sky remains clear and a yellow crescent moon with red border lights the scene from the upper right. Heads of many crewmen can still be seen protruding above the rail.

The narrative continues in "No. 2 Represents … Ship Postillion on her Beam End and Masts cutt away" as Bowen describes attempting to "put our helm alee" to the squall. "But the ship not having full sail would not stay and dropt into the breach. And now came on our bad fate. Boon Island Ledge took us up, where we lost our Captain and Six Men. Got our Runners and Takels up, hove out our small boat which sunk immediately. About 8 O'Clock we cut away our Masts and threw five of our guns Over Board. At 1 O'Clock we left the Wreck, and landed at Wells Bay."

In the final scene, the *Postillion* has completely capsized, with keel to the sky, while a crowded long boat rows away. The sea remains choppy and the sky clear. The text accompanying "No. 3 Represents the Ship Postillion's Long Boat With 17 of her men leaving the Wreck" is a list of individual crew names, indicating whether they survived or drowned.[4]

Bowen was a respected mariner in his day whose accounts, both textual and visual, were no doubt considered to accurately portray incidents without undue embellishment. By including details that would be of interest only to mariners, such as shifting wind directions, he shows his command of the events depicted, investing his painting with an authority not accessible to artists without first-hand maritime experience. Bowen's name does not appear on the crew list, so apparently he was not on scene as a participant. But the painting implies first-hand communication between the artist and an on-scene witness who, as members of the fraternity of seamen, would have held a common understanding of events.

Observational authority was a privileged discourse through which certain paintings, and by extension artistic reputations, achieved elevated status. While Ashley Bowen became established in the parochial seafaring community of colonial Marblehead, Dominic Serres (1719-1793) was a contemporary who parlayed similar nautical knowledge along with significant artistic and social skills into international renown as a marine artist. Much is still not known about his early life, but that which is suggests a meteoric rise through ambition and skill. He was born in France, became a sailor, and during the Seven Years War was captured and imprisoned in England. Upon release he rapidly transformed himself into a marine painter of high social standing. He was a founding member and librarian of the Royal Academy, and was appointed Marine Painter to George III in 1780.[5] Further cementing his reputation posthumously, his son John Thomas released his father's book

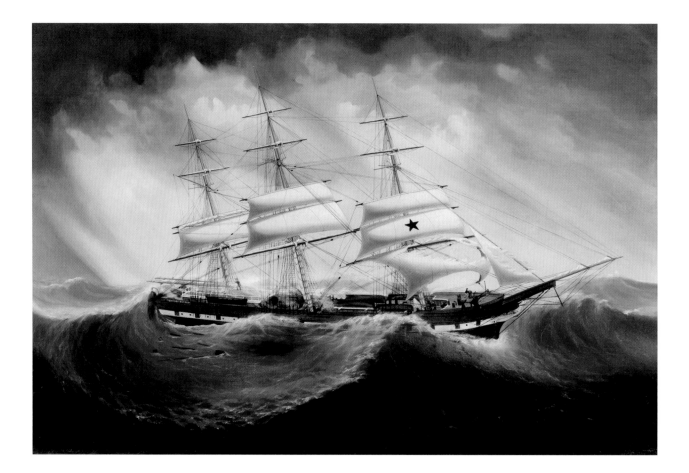

William G. Yorke (British, 1817–1888)

Packet Ship Bridgewater, 1867

Oil on canvas, 24 x 36 in.

Courtesy James C. and Virginia W. Meade

Dominic Serres (British, 1722-1793)
HMS Amazon *overset in a gale off the Island of Martiniqua, October 1780*, n.d.
Ink and wash on paper, 12 x 17 in.
Peabody Essex Museum, Salem, Massachusetts

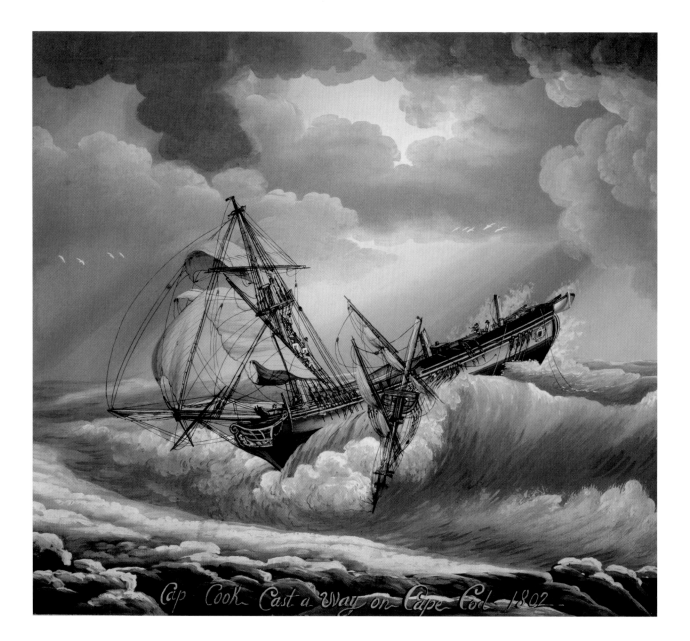

Michele Felice Cornè (American, ca. 1752-1845)
Cap Cook Cast a Way on Cape Cod 1802, n.d.
Gouache on paper, 13½ x 15½ in.
Peabody Essex Museum, Salem, Massachusetts

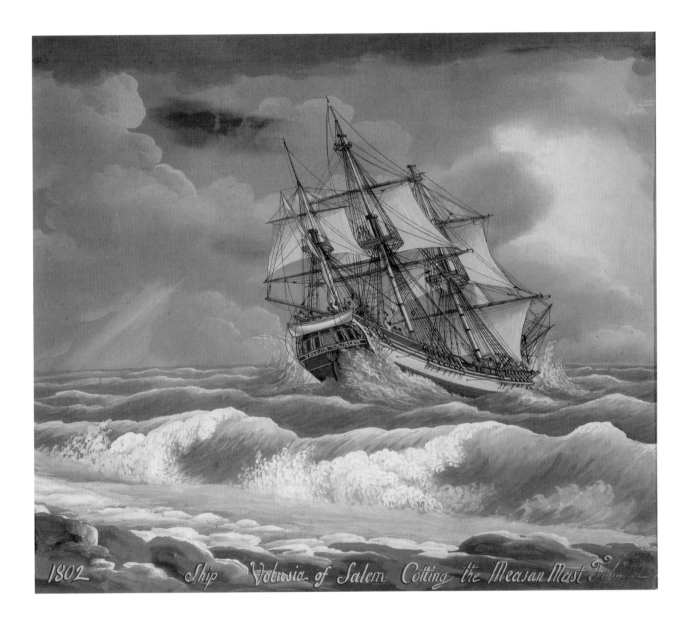

Michele Felice Cornè (American, ca. 1752-1845)

Volusia *of Salem Cotting the Measan Mast February 22 1802*, n.d.

Gouache on paper, 13½ x 15½ in.

Peabody Essex Museum, Salem, Massachusetts

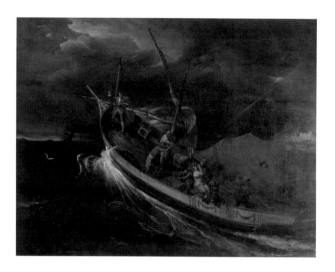

Liber Nauticus and Instructor in the Art of Marine Drawing (1805), insuring his lasting influence on the British marine tradition.

The year Serres was appointed marine painter to King George, the Caribbean islands were hit by the most destructive of all recorded hurricanes. His wash drawing *HMS* Amazon *overset in a gale off the Island of Martiniqua, October 1780* (cat. 61; p. 87) focuses on a relatively minor incident in the four-day storm. Besides the loss of the thirty-two–gun British warship, an entire French convoy fleet of forty ships carrying 4,000 soldiers was sunk off Grenada while the entire British fleet off St. Lucia was destroyed. It is estimated that 22,000 people died on the islands of Barbados, St. Vincent, St. Lucia, and Martinique alone, but the maelstrom continued northward up the archipelago causing undocumented destruction as far as Puerto Rico.

Rather than creating a picture in defense of the actions or decisions of the crew, this image presents their predicament in the midst of events far beyond their control, an environmental and human disaster of monumental scale. Most of the artist's works address subjects intended for grand homes and public display, but this wash drawing takes a decidedly more intimate approach. Unlike many of his works on paper, no corresponding large format oil is known to exist of this subject. Perhaps it was a preparatory sketch for a larger work that was never completed, but it is also possible that this wash was considered his finished presentation of the subject, created for an individual survivor on board the ship. He did produce at least one major oil painting of a related subject, *The Shipwreck of the* Phoenix *at Night*, which also occurred during the hurricane.

Serres had credentials as a sailor and drew upon sophisticated nautical knowledge for his painting. Though unlike other artists with seafaring roots, he not only found recognition well beyond the maritime community, but actively sought inspiration through study and interaction with great European artists. Serres formed an enormous art collection that included works by maritime masters

Fig. 22
Horace Vernet (French, 1789-1863)
Joseph Vernet Tied to a Mast in a Storm, 1822
Oil on canvas, 108¼ x 140³⁄₁₆ in.
Musée Calvet, Avignon. Photography © André Guerrand

like Brooking, Capelle, Cuyp, Lorrain, Vernet, Canaletto, Monamy, van Goyen, Storck, Webber, and over 200 drawings and several paintings by the Van de Veldes.[6] Serres struck up a correspondence with Claude Vernet in 1775 and the two artists exchanged drawings and gouaches for several years. In his letters, Vernet was invariably gracious with Serres, noting in a critique of a drawing that he found "the perspective very good, also the ships very well done, in a marine style." Vernet closed another letter by noting the links between them, "the same nationality, the same profession, the same genre and, I flatter myself, the same mode of thought."[7] It is likely that the mode of thought he refers to involves their common expository approach to the genre to which they are both primarily associated.

More than thirty years after Vernet's death, the practice of observation that was so valued by the artist was transformed from a technical principle into a central tenet of Romantic painting. During and shortly after his life, an undocumented story about Vernet had circulated to no great affect that during a great storm on a Mediterranean voyage he had decided that, rather than go below to safety, to have himself tied to the mast to observe the effects of the storm first hand. From Vernet's perspective, he was probably taking the opportunity to gain first-hand exposure that could be drawn on in future paintings. But in 1822, his grandson Horace Vernet painted *Joseph Vernet Tied to a Mast in a Storm* (fig. 22), a heroic presentation of the event that has been interpreted as Claude's dismissal of danger in his pursuit of the sublime.[8] Claude probably thought of his actions as a natural quest for authenticity, a responsible practice in the tradition of marine artists such as Willem van de Velde the Elder who sailed out to naval battles to observe and sketch them on site. But by the nineteenth century when topographical (and marine) paintings had taken on overt spiritual dimensions, his grandson Horace dismissed documentary realism in favor of the Romantic ideal.

In Federal-period America, maritime specialization for a professional artist was supported largely through professional affiliation. In 1799, Michele Felice Cornè departed Naples for the United States to establish himself as its first professional marine painter. The enterprising artist had probably perceived the niche while painting commissions from American mariners visiting Naples, so he boarded the *Mount Vernon*, owned by Elias Hasket Derby, and settled for awhile in Salem, Massachusetts. He became an informal artist-in-residence to the East India Marine Society, a group of mariners with vast international trading experience, and in addition to portraits of their ships and incidents at sea, he drew on print sources to paint scenes of Africa, Europe, and the Pacific for their homes and the society meeting hall.

When Cornè had been in Salem for only two years, a great disaster befell the town. In February 1802, three ships departed on a long voyage to Europe and Asia, but only one day out they encountered a gale with heavy snow. All three ran up on the beach at Provincetown, Cape Cod, and two were pounded to bits in the surf. As the crews came ashore and sought shelter, nine of fourteen crewmen on the ship *Brutus* froze to death. Though residents of Salem were wary of their fate as the gale blew through, it was not until ten days afterward that they received specific news of the calamity in the form of letters written by the two surviving masters to the ships' owners.

In *Cap Cook Cast a Way on Cape Cod 1802* (cat. 17; p. 88), Cornè presents the ship *Ulysses* amidst the surf at the moment she struck the beach. Though the events occurred in heavy snow during a New England winter night, Cornè only made relatively minor modifications to his Mediterranean palette, and the contrasting bright and dark colors evoke a sense of alarm in the viewer. Similarly, Volusia *of Salem Cotting the Measan Mast February 22 1802* (cat. 18; p. 89) portrays the crucial moment when the ship approached the shore and the crew cut the rigging down so the wind would not tear the ship to pieces. *Volusia* fared the best of the three ships, and her bilged hull was eventually restored and the ship refloated.

Samuel Walters (British, 1811-1882)

Ship Nonantum, 1842

Oil on canvas, 23½ x 35½ in.

Peabody Essex Museum, Salem, Massachusetts

Samuel Walters (British, 1811-1882)

Steamer Pacific, ca. 1852

Oil on canvas, 37¼ x 47½ in.

Peabody Essex Museum, Salem, Massachusetts

The local newspaper concluded its initial report of events by noting that "the town of Salem sustains a great loss of property, and what is of vastly more value, as the lives of men are above all price, the loss of many worthy and respectable young men."[9] It is possible that Cornè created a third painting of the ill-fated *Brutus*, but it seems significant that these two paintings portray the ships in which all the crew survived, and the moment at which they were all at greatest risk. *Ulysses* and *Volusia* were commanded by brothers James and Samuel Cook, and though a tragic financial loss, the survival of the crews was a testament to their perseverance during an unavoidable tragedy.

The growth of documentary marine painting and the privileging of both nautical knowledge and first-hand observation reached its apogee in the ship portraits in oil produced by Liverpool-based artists like Samuel Walters (cats. 75-77; pp. 80, 92, 93). Some of these painters are known to have worked from sail plans or even to have measured the ships they painted to obtain the valued accuracy of presentation. William G. Yorke was a later practitioner in this tradition, whose early career was based in Liverpool, but who migrated across the Atlantic to New York by 1871. His painting of the ship *Bridgewater* (cat. 80; p. 86) captures the vessel in the late 1860s when she was operating as a New York-to-Liverpool packet for Williams & Guion's Black Star Line. The insignia of the company, displayed prominently on the lower topsail of the foremast, is the single most characteristic feature of the ship.[10] Even with this obvious promotional attribute, it is evident that Yorke did not create the painting for public display to enhance the reputation of the line. *Bridgewater* is portrayed with a huge wave washing across her deck, with barrels and other flotsam in the foreground that have been washed overboard. A small boat dangles from one davit at the stern while another has become unlashed and rattles dangerously amidships. Both a mainsail and jib have been blown out by the storm, but the ship retains other sails intact for stability and the hull stands secure and without heel. Several crewmen appear around the deck, performing duties necessary for their safety. The storm depicted does not seem to be documented beyond this painting, so it was most likely based on the memory and description of one of those figures depicted.

Yorke painted at least two other canvases of the *Bridgewater*, both in happier circumstances while under full sail in mid-ocean. One he signed "William G. Yorke" along with his address on Fulton Street in Brooklyn, having adopted the final vowel in his last name in mid-career.[11]

Bridgewater had a long life beyond that of a transatlantic packet. She was constructed in 1855 by the preeminent Philadelphia shipbuilder William Cramp, and operated out of New York for many years. By the 1880s she was owned by Mary Eliza Allen of Boston with Jonathan H. Allen as master.[12] Perhaps it was inevitable that, although she escaped the storm depicted by Yorke, the ship eventually fell victim to another at the end of her long career. In December 1889 she departed Darien, Georgia, with a cargo of lumber and crew of eighteen, but never arrived at her destination of Queenstown, Ireland. She was reported a loss in April 1890.[13] Coincidentally, the life span of the *Bridgewater* largely paralleled that of Yorke himself, so it is fitting that he revisited this subject on several occasions. By the early 1890s, Yorke was blind and disabled, living on a hulk tied to a pier in Brooklyn. Demand for marine painting in the documentary tradition commanded very little interest, and that which was produced reflected the interests of companies rather than of individuals.

The subjective measurement of a work within the hierarchy of marine painting, and by extension its creator, has traditionally been based on the quasi-objective assessment of authenticity by those assumed to be the primary viewers of the work, namely sailors. The enlightenment principles that elevated the values of science (which gave rise to private commercial voyaging) also provided the tools by which images of those subjects were assessed. In early America, independence on the seas brought a need for adroitness and adaptability to both environmental and

commercial challenges. The manipulation of ships and the commercial systems that drove them spawned interest in artistic representations of seafaring successes as well. Thus, events such as hurricanes, rogue waves, and encounters with the coast or submerged obstructions took on significance beyond the challenges of nature, but represented the technological savvy and fortitude of character of the ship's operators and owners. By extension, such marine paintings were both document and allegory for humanity's destiny in a modern age.

Endnotes

[1] Melville, Herman. *Moby-Dick*, chapter one, 1851.

[2] Daily Journal of Frederick Jordan Ranlett, September 26, 1874. Manuscript property of John Ranlett.

[3] Smith, Phillip Chadwick Foster, ed. *The Journals of Ashley Bowen (1728-1813) of Marblehead*. Peabody Museum of Salem and The Colonial Society of Massachusetts, 2 vols., 1973.

[4] "List of Men's Names was on Board the *Postillion*. Note the letter (d) for the drowned.
Capt. Friend d., Cmt [1st mate] T. Peters, Sd.m. [2nd mate] F. Bates d., B. Wm. Healey, T. Laskey, T. Friend d., E. Seery, P. S. Norton, S. Coffen, B. Swain, J. Chapman d., S. Caswel, T. Trefry, R. Prince, L. Coffen d., N. Barker, T. Otis, T. Innis, S. Eden d., T.Hubbard, A. Folger d., B. Sprage, N. Folger, A. French"

[5] Russett, Alan. *Dominic Serres R.A. 1719-1793: War Artist to the Navy*. Antique Collectors' Club, 2001.

[6] Ibid.: 131.

[7] Ibid.: 117.

[8] Levitine, George. "Vernet Tied to a Mast in a Storm: The Evolution of an Episode of Art Historical Romantic Folklore." *The Art Bulletin*, 49: 2: 93-100, 1967.

[9] Melancholly (sic). *The Register*. Salem, Massachusetts, Monday, March 8, 1802.

[10] Hartshorne, Richard and John F.H. King. *American Lloyd's Register of American and Foreign Shipping*. New York, 1867.

[11] Peabody Essex Museum photo files.

[12] *General List of Merchant Shipping in All Nations*. No. 58. Paris: Bureau Veritas, 1886.

[13] *Alphabetical List of Ship Registers, District of Boston, Massachusetts, 1802-1860*. Vol. 1. Boston: Works Progress Administration, 1939: Hartshorne, Richard and John F. H. King. *American Lloyd's Register of American and Foreign Shipping*. New York: R.C. Root, Anthony & Co., 1857.

Thomas Birch (American, 1779-1851)
The Ship Ohio, 1829
Oil on canvas, 20¼ x 30¼ in.
© Shelburne Museum, Shelburne, Vermont

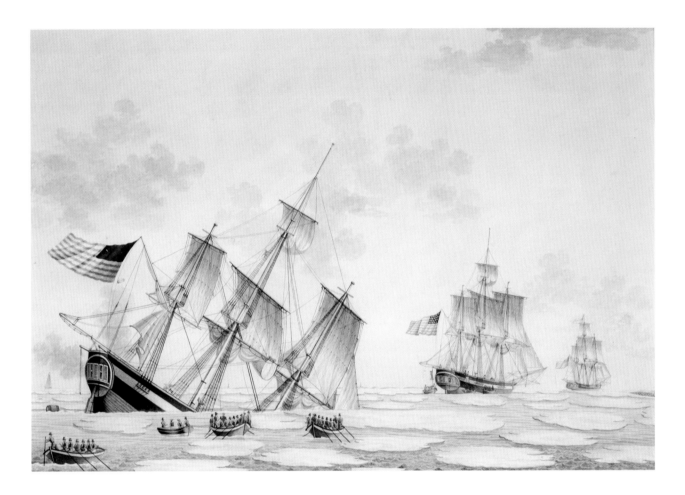

Jan Mooy (Dutch, 1776-1847)
Ship Janson *Cut Through by Texel River Ice*, n.d.
Watercolor on paper, 14¾ x 20¾ in.
Peabody Essex Museum, Salem, Massachusetts

James Edward Buttersworth (American, 1817-1894)
Flying Cloud *Rounding Cape Horn*, n.d.
Oil on canvas, 20 x 30 in.
Courtesy James C. and Virginia W. Meade

James Edward Buttersworth (American, 1817-1894)
British Steamer Gallia *in a Storm*, 1880
Oil on canvas, 23¾ x 35½ in.
Peabody Essex Museum, Salem, Massachusetts

Jasper Francis Cropsey (American, 1823-1900)

The Cove – A Storm Scene in the Catskill Mountains, 1851

Oil on canvas, 59 ¹³⁄₁₆ x 47 ⁵⁄₁₆ in.

© The Cleveland Museum of Art, Gift of The Horace Kelley Art Foundation

The Eye of the Storm:
Symbols and Expressions in Nineteenth- and
Early Twentieth-Century American Art

~⋙

MARK D. MITCHELL

The history of American art is rife with storms. From Thomas Cole's iconic *View from Mount Holyoke, Northampton, Massachusetts, after a Thunderstorm (The Oxbow)* of 1836 (fig. 23; p. 102) to Winslow Homer's powerful *The Gulf Stream* of 1899 (fig. 24; p. 102) and beyond, storm scenes constitute a sizeable proportion of the canonical masterworks of American art of the nineteenth and early twentieth centuries. At first glance, the power of the storm appears to offer both an adequate and intuitive explanation for its frequent recurrence as an artistic trope in landscape, history, genre, and portrait paintings alike. Massive cloud banks, sharp contrasts of lighting, and vivid atmospheric effects are certainly easy indicators of dramatic content. That limited perception of the storm's formal potential, however, shows only one aspect of the picture.[1]

Depictions of storms in American landscape art of the nineteenth and early twentieth centuries operate in two dimensions that distinguish them from most other natural subjects: flexible symbolism and dynamic expressionism. Flexible symbolism refers to the ability to embody multiple, even opposite, meanings such as good or evil, birth or death. Dynamic expressionism refers to the ability to evoke a similarly broad array of emotions. Over time, artists' representations of storms would favor one dimension or the other, progressing steadily toward the expressive in the later decades of the nineteenth century under the influence of contemporary intellectual and historical developments.

An early example of the storm's symbolic range in American art is manifested in Cole's series *Voyage of Life*, which was originally painted in 1839-1840 and widely distributed through a set of masterful engravings by James David Smillie during the mid-1850s. Cole was recognized even then as a leader of the American school of landscape painting, later dubbed the Hudson River School, and his influence is difficult to underestimate. In *Childhood* (fig. 17; p. 67), a baby emerges from the shadows of a cavern to begin his journey down the allegorical river of time under the care of his guardian angel. In this composition, the swirling mass of clouds above the mountainside is associated with genesis, the nebular chaos from which life was formed.

In the penultimate scene of the voyage, *Manhood* (fig. 19; p. 67), the infant has grown to middle age and has abandoned his guardian, who nevertheless continues to look on from above. The man prays for salvation as he sees that his route has led him into danger. The rapids ahead are haunted in the tempestuous sky overhead by three apparitions that the artist identified as "suicide, intemperance and murder."[2] This later scene portrays the opposite meaning of the storm. Whereas in *Childhood* the storm symbolized creation, in *Manhood* it represents danger and death. In *Old Age* (cat. 15; p. 68), the final image in the series, the figure at last emerges from the rapids into the calm, open sea and the clouds part in the sky above.

This single series provides an important and widely-known model of the storm in diametrically contrasting

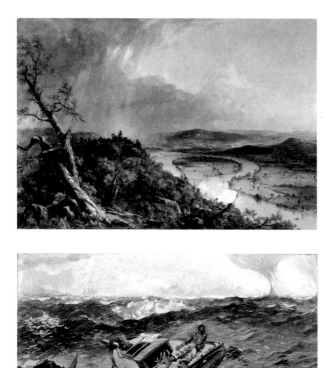

roles, both of which are characteristic of the motif's early history in American art. Of note, only rarely, if ever, does the storm in its early, most symbolic form suggest a meaning anywhere in between such sharp polarities: birth and death, creation and destruction. As a representative of the storm at its most keenly symbolic, Cole's *Voyage of Life* was significant not only because it was widely seen and discussed, but also because it served as a touchstone for subsequent generations of American landscapists.

Symbolic meaning is, however, unusual in Cole's series for its overtness; what the art historian Lorenz Eitner has aptly termed "baldly stated allegory." As Eitner has observed, the more common mode of romantic symbolism during the period was less obvious, "a symbol hidden under the appearance of casual reality," rather than its more "frank" cousin.[3] Reality and realism are, of course, relative terms, and very little early or mid–nineteenth-century American art fits comfortably under their rather permeable umbrella. Jasper Cropsey's idyllic *Passing Shower on the Hudson* (cat. 20; p. 103) and his impressive *The Cove - A Storm Scene in the Catskill Mountains* (cat. 21; p. 100), for example, offer close equivalents for the meanings so bluntly phrased in Cole's *Voyage of Life*, but thinly veiled in the cloak of the actual sites in the American landscape.

Cropsey's peaceful *Passing Shower* implies no danger in the coming rain. Instead, the cattle in the foreground appear unconcerned with the impending storm, going about their business with casual indifference. The modest storm promises what Thoreau called "fertilizing rain," rather than a deluge.[4] In Cropsey's *Passing Shower*, rain plays a vital role in the cycle of nature, sustaining life and promoting prosperity for the town in the distance. Within the context of an ostensibly realistic, rather than allegorical, landscape, Cropsey's scene nevertheless asserts unambiguous symbolic meaning.

At the opposite end of the spectrum, again almost diametrically opposed in meaning, stands Cropsey's *The Cove*.

Fig. 23
Thomas Cole (1801-1848)
View from Mount Holyoke, Northampton, Massachusetts, after a Thunderstorm (The Oxbow), 1836
Oil on canvas, 51½ x 76 in.
The Metropolitan Museum of Art,
Gift of Mrs. Russell Sage, 1908

Fig. 24
Winslow Homer (American, 1836-1910)
The Gulf Stream, 1899
Oil on canvas, 28⅛ x 49⅛ in.
The Metropolitan Museum of Art,
Catharine Lorillard Wolfe Collection, Wolfe Fund, 1906

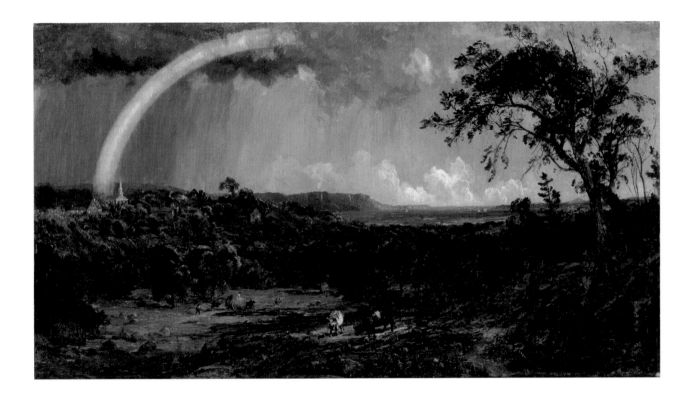

Jasper Francis Cropsey (American, 1823-1900)

Passing Shower on the Hudson, 1885

Oil on canvas, 13 ¹⁵/₁₆ x 25 ½ in.

Davis Museum and Cultural Center,

Gift of Mrs. Leeds A. Wheeler (Marion Eddy, Class of 1924)

Straining against the boundaries of realism, Cropsey's composition is an achievement in the pursuit of the sublime. The juxtaposed looming storm and blasted tree trunk in the foreground offer an excellent vision of the power and scale of nature. The conflict of sky and earth is a mortal theme, as the shattered tree suggests. The artist wrote in 1855 that the storm cloud "is perhaps in its grandest moods more impressive than all the other cloud regions-awakening the deepest emotions of gloom, dread, and fear; or sending thrilling sensations of joy and gladness through our being."[5] In scale, palette, and composition, *The Cove* favors the former interpretation.

In both its purely allegorical and more realist guises, the storm in early and mid–nineteenth-century American art was primarily symbolic in function. With a clear grammar of relative scale, chiaroscuro, and atmospheric effects, artists such as Cole and Cropsey invoked abstract meaning that is readily understood and moralizing in tenor. In the case of James Hamilton's 1863 Old Ironsides (cat. 27; p. 32) that significance even rose to the level of national significance as the Revolutionary era vessel was portrayed in heroic terms that offer a visual equivalent to the 1830 poem of the same name by Oliver Wendell Holmes.[6] The specificity of meaning in these storm scenes also bears more than a passing resemblance to the structure of language, which suggests that this form of symbolism might appropriately be characterized as literary-symbolic. The shared poetics of literature and of art during the era were at least partially the product of the close relations between artists and writers as famously "kindred spirits." The storm was a common motif in both forms, witnessed in allegorical poems by William Cullen Bryant such as "After a Tempest" in which the storm is a metaphor for conflict, in John Greenleaf Whittier's "Snow-Bound" as a sign of lost faith, and in Cole's own "Lament of the Forest" in which the storm symbolizes the ravages of man's hubristic advance into the wilderness.

During the mid-century, a modified form of the prevailing literary-symbolic mode entered ascendancy, par-

alleling the rise of popular science and the seemingly inexorable westward expansion of the nation. Of particular relevance to our subject, meteorology gained immense popular traction as new technology and methods began to unravel the mysteries of the weather. Complemented by the rise of the highly influential British critic John Ruskin's aesthetic doctrine of specificity in natural detail, the stormscapes of mid-century illustrate what art historian Barbara Novak has termed the "meteorological vision" in American art.[7] The science of weather was something of a novelty, one closely followed by landscape artists in their pursuit of nature. The nomenclature of cloud types, in fact, was only developed by a British scientist, Luke Howard, at the beginning of the century, laying the foundation for subsequent studies of the how and why of their formation. By mid-century, active debates ensued around the nature and origins of storms in scientific circles, and the storm's multiple aspects and complex phenomena came forward with ever greater force and resonance in art.[8]

Storms, then as now, were the subjects of considerable curiosity and frustration within the scientific community. Three Americans-James Pollard Espy, William Ferrell, and Elias Loomis, aggressively studied weather patterns and formulated the influential "thermal theory" of storm development during the 1840s and 1850s. Meanwhile, Joseph Henry, the first director of the Smithsonian, established a network of "synoptic," or simultaneous, observation stations throughout the American Midwest that generated the first regional weather maps, enabling more systematic study of weather patterns and movement.[9] As prediction improved, the storm, though always a powerful force of nature, came increasingly under the control of scientific understanding and description, which would exert a considerable influence on art.

Traveling through the Southwest, in what Smithsonian director Henry called a "natural laboratory for the study and advancement of meteorology" because of its location at the intersection of tropical and polar air masses

that often resulted in dramatic storms, Thomas Moran created highly specific depictions of the region's natural phenomena, mapping the western territories for the benefit of East Coast audiences. Moran's compositions, including his *Mountain Valley* (cat. 52; p. 56) and *Grand Canyon* (cat. 50; p. 57), navigate between the essentialized grand gesture of the earlier tradition represented by Thomas Cole and the scientific spirit of mid-century. Moran's clouds are just one facet of a complex meteorological system unique to the region and closely observed by the artist. The density of air as the pressure builds ahead of the storm; filtered sunlight bathes the landscape in color; and, of course, the nimbus clouds are readily identified by their color and mass. Moran's depictions may be characterized as symbolic representations of impending destruction balanced by careful scrutiny to reinforce the characteristic forms of nature with awed fascination.

Frederic Edwin Church similarly infused the more grandiose elements of the North and South American landscapes, which he explored widely, with a meteorological specificity that bridges the storm's literary and scientific symbolic modes at mid-century. His *Rainy Season in the Tropics* (fig. 25) was begun during a particularly bleak moment during the Civil War in 1864 and completed in its aftermath in 1866. The work has been read by National Gallery curator Franklin Kelly and others as a celebration of the reunified American republic.[10] Church's dedication to accuracy of natural effects, a hallmark of his work and that of numerous contemporaries, extended primarily to the details and rarely to the overall composition, however, which Church freely reorganized in the interest of symbolic effect. Working in the tradition of his teacher, Thomas Cole, Church readily imbued his stormscapes with symbolism, here as unity and hope in the storm's wake. Church's magnificent double rainbow is a powerful storm sign, used repeatedly as a symbol of man's covenant with God and, in natural terms, the restoration of hope in the storm's aftermath.[11]

Fig. 25
Frederic Edwin Church (American, 1826-1900)
Rainy Season in the Tropics, 1866
Oil on canvas, 56 ¼ x 84 ¼ in.
Fine Arts Museums of San Francisco,
Museum purchase, Mildred Anna Williams Collection, 1970.9

As Church's composition suggests, faith and science were generally considered to be complements, rather than antagonists, during much of the nineteenth century, at least until Darwin's publication of *On the Origin of Species* in 1859. Both faith and science sought a deeper understanding of truth through the study of natural creation. Storms offered a frequent reminder of the constant and elusive presence of the divine in nature, one that eluded simple characterization.

The Civil War era marked a watershed in the depiction of storms in American art, during which time the symbolic mode of the storm entered the first stages of eclipse. The disruption to American life and culture that the war embodied called for new artistic means with which to contend with an equally new reality. The storm offered a resonant natural form to embody the resulting introspection and subjectivity. Expressionism, the second key dimension of storms advanced to fill a need and would continue to resonate with varied American cultural preoccupations into the mid-twentieth century.

As Church's *Rainy Season in the Tropics* suggests, a storm is often a crucible from which the landscape emerges transformed. Storms were similarly deployed in American art and history to represent change, conflict, and unrest. The storm that accompanied Washington's march to Trenton during the Revolution symbolized the turning point in the tide of the war. In art, the storm in Emanuel Leutze's *Washington Crossing the Delaware* (fig. 26) of 1851 may be read similarly as a sign of the emergence of the Continental Army from its darkest days. In both history and art, the storm of the march to Trenton was considered an omen.[12] In American and European history paintings of the late eighteenth and the early and mid-nineteenth centuries such as Leutze's, storms offered an expressive backdrop for heroic action. As these grand narratives subsided in popularity, however, by the Civil War era, national conflict was increasingly phrased in natural terms.

When the impending crisis of the 1850s gave way to secession and Civil War during the early 1860s, storm

Fig. 26
Emanuel Leutze (American, 1816-1868)
Washington Crossing the Delaware, 1851
Oil on canvas, 149 x 255 in.
The Metropolitan Museum of Art, Gift of John S. Kennedy, 1987

scenes in art reached new expressive heights and manifested national strife. Martin Johnson Heade's powerful storm series, including the preternatural darkness of his *Approaching Thunder Storm* (fig. 27) of 1859, is widely accepted as a manifestation of the building psychological tension. Heade's scene achieves an intensity and poignancy not seen before in American stormscapes. As the full power of the storm appears ready to unleash itself on the landscape, the figure in the foreground sits smoking a pipe, as if resigned to the coming darkness. Unlike Cole's allegorical *Manhood*, Heade's figure does not pray for forgiveness; he waits. Heade's treatment of the storm is prescient, rather than retrospective, filled with an uncanny feeling of psychological intensity and suspense.

A four-decade-long series of storm scenes begun by William Trost Richards shortly after the conclusion of the Civil War illustrates the evolution of the storm motif during the later nineteenth century from an expression of national unease to a more personal emphasis. Richards experienced the storm as a crucible more directly than most artists. According to his children, Richards' ship encountered a vicious winter storm in late 1867 when the artist was returning to New York from an extended trip in Europe. The weather forced the steamer out to sea just as it neared New York harbor and almost destroyed the ship over the course of three days, covering it in ice, crushing the wheel house, and depleting the store of coal, before abating.[13] That experience apparently enraptured the artist. In the subsequent four decades, he would make the storm-wracked coast a primary theme of his art, including his powerful *Lands End, Cornwall* (cat. 58; p. 111). Working in oil, watercolor, and graphite, Richards documented the storm's incredible complexity of form and expression, and demonstrated its infinite potential as source of artistic inspiration. His stormy coasts rarely, if ever reach to either the apocalyptic or Elysian extremes, exploring instead a range of suggestive moods from tense expectancy to hopeful optimism.

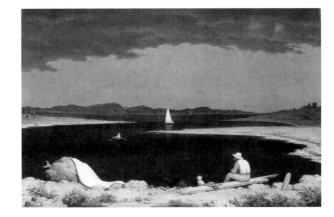

Fig. 27
Martin Johnson Heade (American, 1819-1904)
Approaching Thunder Storm, 1859
Oil on canvas. 28 x 44 in.
The Metropolitan Museum of Art,
Gift of the Wolf Foundation and Mr. and Mrs. Erving Wolf, 1975

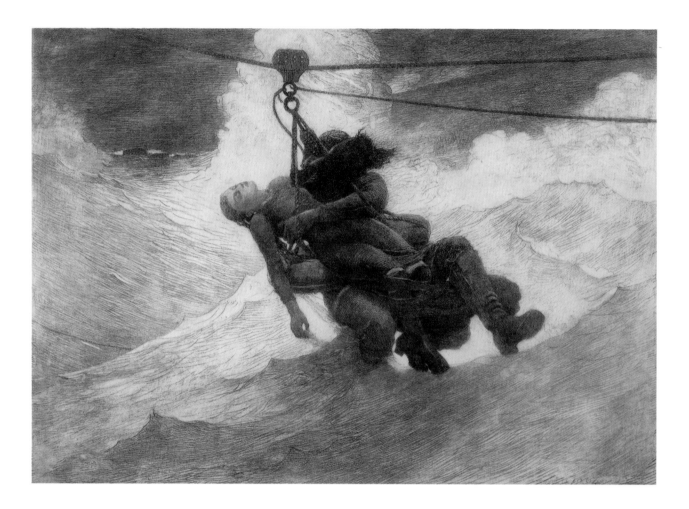

Winslow Homer (American, 1836-1910)
The Life Line, 1884
Etching in green ink with aquatint and drypoint, 17½ x 23 in.
Brooklyn Museum, Carl H. de Silver Fund

The competing realist modes of art of the later nineteenth century offer an excellent opportunity to revisit the idea of the intrinsic variety of storms as both symbols and expressions in art. The temptation to contrast storms with clear skies, rather than with other storms as a means of understanding their range can be tantalizing, particularly later in the century. The opposition of a storm and a clear day in the later century adopted the significance of a clash of entire systems of knowledge, however, not merely of meanings. The storm came increasingly to embody psychological force and mood, in other words subjectivity. Winslow Homer's *Winter Coast* (fig. 28) portrays the fury and force of the storm's wrath confronted by his intrepid hunter, much as the figures in his *The Life Line* (cat. 35; p. 108) are subsumed within the violence of the heavy surf, held aloft by only a thin rope stretching from a foundering ship to the safety of shore. The expressiveness of Homer's scenes is highlighted by contrast with the implacable objectivity of Thomas Eakins' famous *The Champion Single Sculls (Max Schmitt in a Single Scull)* (fig. 29). The clarity of daylight reveals and delineates, whereas Homer's storm, like the night, suggests and obscures. Whereas artists such as Homer, Heade, and Richards portray the range of climatic expressions in nature, Eakins' objectivity suggests clinical detachment, or the dearth of emotion altogether. Eakins' objectivity, a thin veneer from the outset, proved short-lived, whereas Homer's more emotive approach continued unabated well into the twentieth century.

The storm's expressive form adopted new vitality in the eyes of Albert Pinkham Ryder during the 1890s. To Ryder, as seen in his *Flying Dutchman* (fig. 30), the swirling masses of stormy sea and sky take on lives of their own. Their depth, both literally in the layered pigment as well as psychologically, are excellent metaphors for the artist's struggle with his medium to achieve his expressive ends. As Ryder worked and reworked his composition as was his characteristic style, a personal accretion manifested itself in the scene over time. Like a palimpsest of experience and

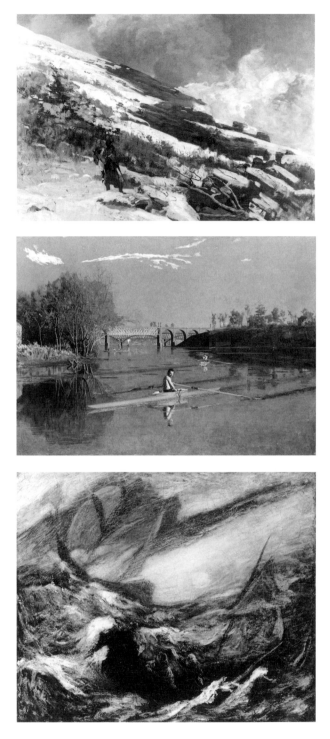

Fig. 28
Winslow Homer (American, 1836-1910)
Winter Coast, 1890
Oil on canvas, 36⅛ x 31¹¹⁄₁₆ in.
Philadelphia Museum of Art, The John G. Johnson Collection

Fig. 29
Thomas Eakins (American, 1844-1916)
The Champion Single Sculls (Max Schmitt in a Single Scull), ca. 1871
Oil on canvas, 32¼ x 46¼ in.
The Metropolitan Museum of Art, Purchase, The Alfred N. Punnett Endowment Fund and George D. Pratt Gift, 1934

Fig. 30
Albert Pinkham Ryder (American, 1847-1917)
Flying Dutchman, 1887
Oil on canvas, 14¼ x 17¼ in.
Smithsonian American Art Museum, Gift of John Gellatly

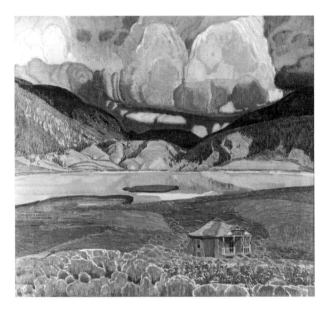

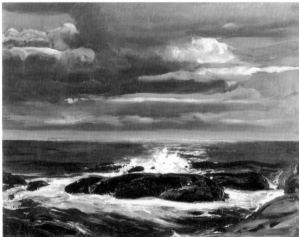

Fig. 31
Ernest Blumenschein (American, 1874–1960)
The Lake, n.d.
Oil on canvas, 24⅛ x 27 in.
National Academy Museum, New York

Fig. 32
George Bellows (American, 1882-1925)
The Sea, 1911
Oil on canvas, 34 x 44⅛ in.
Hirshhorn Museum and Sculpture Garden, Smithsonian Institution,
Gift of the Joseph H. Hirshhorn Foundation, 1966

thought, Ryder's *Flying Dutchman* ascends beyond the poignancy of the black waters below Heade's storm to suggest inner, personal struggle. Ryder's introspective vision would inspire subsequent generations of artists in a manner reminiscent of Cole's work earlier in the century. Medium and technique, in Ryder's hand, became like handwriting, the unique imprimatur of the artist's own self. Engaged with newfound vitality in an era that witnessed the birth of psychoanalysis and popular psychology, Ryder's roiling stormscape suggests the profoundest self-reflection.

In the quest for ever more direct forms of expression at the end of the nineteenth century and the beginning of the twentieth, artists such as Ernest Blumenschein adopted a by then time-honored American tradition of searching for the new: they traveled. Blumenschein, working in the 1920s, turned to the American Southwest in search of more intuitive forms. In the Pueblo cultural traditions, Blumenschein sought a more direct means of expressive effect. In *The Lake* (fig. 31), we see how he distilled the massive storm clouds into blocks of pigment and color. The clouds' block-like forms have mass as well as weight that lend them a physical presence that presses down into the mountain valley below. Blumenschein took his materials and local color usage a step further than most of his peers, hoping to attain a directness of formal terms that could transcend cultural boundaries, tapping a shared basis in human experience that the cultural historian and ethnologist Aby Warburg referred to as *pathosformel*.[14]

Just as at the end of the nineteenth century Ryder sought a more direct means of personal creative expression, a purpose to which the storm lent itself well, in the early and mid-twentieth century, urban artists such as George Bellows found new vitality and directness in their application. It was while summering on Maine's secluded Monhegan Island, however, that Bellows encountered subjects that he felt could inspire him for the rest of his career. One of the four large paintings that resulted from that trip was *The Sea* (fig. 32). There is no ambiguity in the

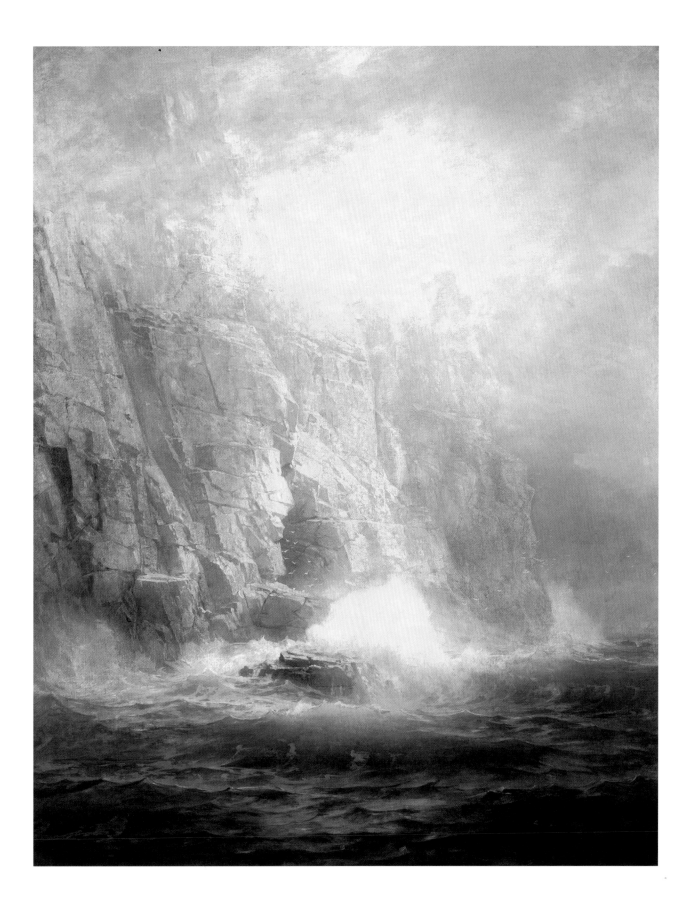

William Trost Richards (American, 1833-1905)
Lands End, Cornwall, 1888
Oil on canvas, 62 x 50 in.
The Butler Institute of American Art, Youngstown, Ohio, Museum Purchase 1919

power of heroic expression that builds in the moonlight in this composition. The artist's powerful stroke, suggestive palette, and hulking forms convey a sense of Bellows' deliberate invocation of personal memory and reverie. The artist's hand is indifferentiable from the forms shown in his landscape, doubly suggestive by the addition of evocative moonlight, transporting us entirely from the daylight objectivity of Eakins into a world of dream and allusion.

By the mid-twentieth century, that sense of interiority or personal projection that emerges so prominently in Bellows' composition may be said to have culminated during the 1940s and 1950s in the direct expressions of Jackson Pollock such as his *One (Number 31, 1950)* (fig. 33). Pollock's skeins of paint cast the maelstrom of the unconscious mind, perhaps more tortured than reflective, onto the canvas with a directness unencumbered by figuration. Nevertheless, in the force and energy of his work, we find the attributes and legacy of the expressive storm, if not its substance.

Despite the expressive extremes to which Pollock and his abstract expressionist peers took abstraction during the mid-twentieth century, a strain of symbolic representation of the storm persisted into that era. In the context of the Depression and the Second World War, artists such as Grant Wood and John Steuart Curry found new meaning and resonance for the storm in their representational works. By no means scientific or realistic in the mid–nineteenth-century senses of the terms, the Regionalists looked to the earlier literary-symbolism of artists such as Thomas Cole to imbue their landscapes, such as Curry's *Tornado over Kansas* (fig. 34), with a resonance in the modern day. Usually, however, the artists opted only for the storm's negative connotations. Almost universally, the artists represented storms as violent, arbitrary, and deadly, rather than the more benevolent, nourishing iteration seen in Cropsey's *Passing Shower*. For artists such as Curry, the storm's symbolic power was a reminder of the ultimate power of nature in an era when industry and technology offered the tantalizing illusion of control over the natural world. Both the symbolic and expressive dimensions of

Fig. 33
Jackson Pollock (American, 1912-1956)
One (Number 31, 1950), 1950
Oil and enamel on unprimed canvas, 106 x 209⅝ in.
The Museum of Modern Art/ Licensed by SCALA, Art Resource, NY

Fig. 34
John Steuart Curry (American, 1897-1946)
Tornado over Kansas, 1929
Oil on canvas, 46¼ x 60⅜ in.
Collection of the Muskegon Museum of Art, Michigan,
Hackley Picture Fund Purchase, 1935.4

storm imagery thus persisted in American art into the mid-twentieth century and continued to evolve with the changing cultural climate. As the nation transformed itself, the varied significance of the storm permitted its constant adaptation to new purposes.

As the observer Adam Badeau wrote in 1859, "American art will be turbulent and impassioned," its artists "emotional, brimful of earnestness, perhaps even stormy," like American nature, "wild and ungovernable, mad at times."[15] Perhaps, then, the storm might be considered a metaphor for American art in general, as much as an expression of the artist in particular. Given the frequency with which the storm appears in even a cursory review of the American canon, its vital and varied contribution to the history of American art makes for fascinating study, as it made for fascinating art.

Endnotes

[1]This essay is developed from a lecture of the same title given at the National Academy Museum in 2004.

[2]Thomas Cole cited in Franklin Kelly, "The Voyage of Life." In Kelly, et. al. *American Paintings of the Nineteenth Century, Part I, The Collections of the National Gallery of Art Systematic Catalogue*. Washington, D.C.: National Gallery of Art, 1996: 107.

[3]Eitner, Lorenz. "The Open Window and the Storm-Tossed Boat: An Essay in the Iconography of Romanticism." *Art Bulletin* 37, 1955: 281-90.

[4]Thoreau, Henry David. *Walden* (annotated ed.). Boston: Houghton Mifflin Company, 1995: 6.

[5]Cropsey, Jasper F. "Up among the Clouds." *Crayon* 2, 8 August 1855: 79.

[6]Holmes' poem sets the history of the vessel in similarly evocative terms, writing that rather than decommissioning the ship a more appropriate fate would be to "give her to the god of the storms,—/ The lightning and the gale!" Oliver Wendell Holmes, "Old Ironsides," in John Hollander, ed. *American Poetry: The Nineteenth Century*. New York: Library of America, 1993: 1:556.

[7]Novak, Barbara. *Nature and Culture: American Landscape Painting, 1825-1875*, rev. ed. New York: Oxford University Press, 1995: 83-4.

[8]Fleming, James Rodger. *Meteorology in America, 1800–1870*. Baltimore: The Johns Hopkins University Press, 1990: 23-54.

[9]Ibid.: 75-93.

[10]Kelly, Franklin. *Frederic Edwin Church and the National Landscape*. Washington, D.C.: Smithsonian Institution Press, 1988: 62.

[11]Ibid.

[12]Groseclose, Barbara S. *Emanuel Leutze, 1816-1868: Freedom is the only King* (exhibition catalogue). Washington, D.C.: Smithsonian Institution Press, 1975: 36.

[13]Morris, Harrison S. *Masterpieces of the Sea: William T. Richards, A Brief Outline of his Life and Art*. Philadelphia: J.B. Lippincott, Company, 1912: 35.

[14]Outlined in Aby M. Warburg. *Images from the Region of the Pueblo Indians of North America* (trans. Michael P. Steinberg). Ithaca, New York.: Cornell University Press, 1995: 15-17.

[15]Cited in Angela Miller. *The Empire of the Eye: Landscape Representation and American Cultural Politics, 1825-1875*. Ithaca, New York: Cornell University Press, 1993: 217.

Thomas S. Moran (American, 1837-1926)

Summer Storm, 1903

Oil on canvas, 24 x 36 in.

The Butler Institute of American Art, Youngstown, Ohio,

Gift of Mr. Alexander J. Revnik 1969

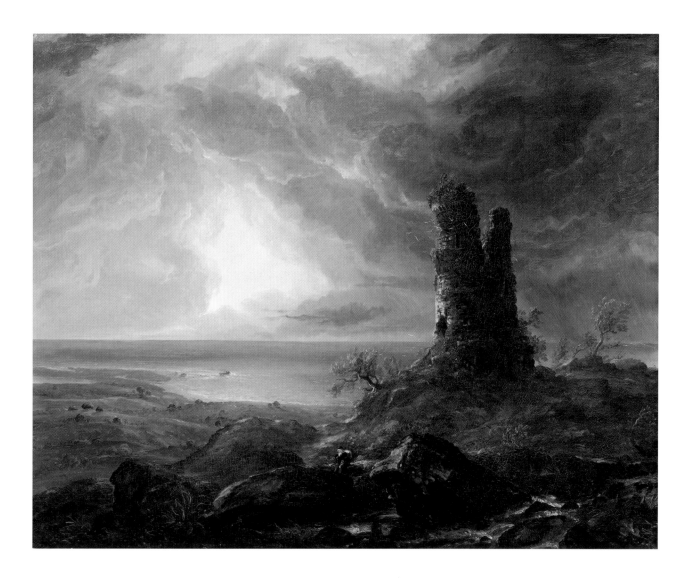

Thomas Cole (American, 1801-1848)
Ruined Tower (Mediterranean Coast Scene with Tower), ca. 1832-1836
Oil on composition board, 26¾ x 34 in.
Albany Institute of History and Art Purchase

Winslow Homer (American, 1836-1910)
Winter at Sea – Taking in Sail off the Coast, 1869
Electrotype from wood engraving, 15¾ x 11⅛ in.
Des Moines Art Center Permanent Collections, Gift of Richard and Kay Ward

Winslow Homer (American, 1836-1910)

On the Bluff at Long Branch, at the Bathing Hour, 1870

Electrotype from wood engraving, 15⅞ x 10¹⁵⁄₁₆ in.

Des Moines Art Center Permanent Collections, Gift of Richard and Kay Ward

John Marin (American, 1870-1953)
Rough Sea, Cape Split, Maine, 1932
Oil on canvas, 22 x 28 in.
Oklahoma City Museum of Art, Museum Purchase

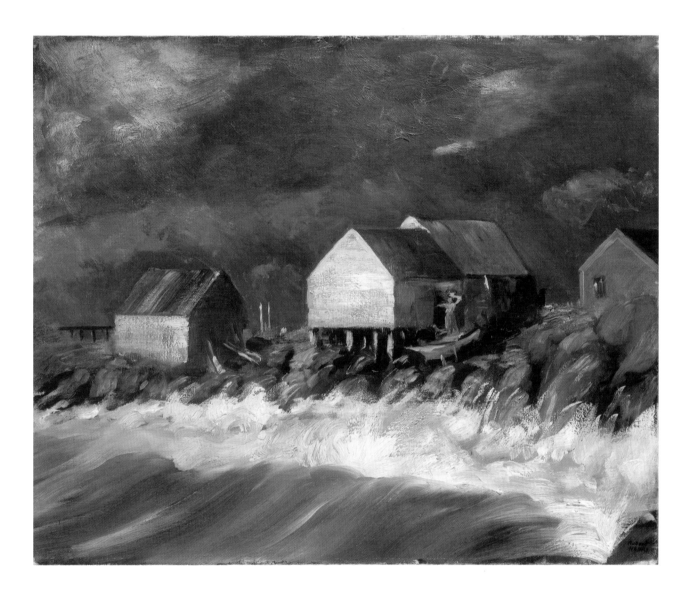

Robert Henri (American, 1865-1929)

Storm Tide, 1903

Oil on canvas, 26 x 32 in.

Whitney Museum of American Art, New York, Purchase

Charles Burchfield (American, 1893-1967)
Landscape with Rain, 1917
Watercolor on paper, 13½ x 19½ in.
Private Collection courtesy DC Moore Gallery, New York

Charles Burchfield (American, 1893-1967)
Lull in Summer Rain, 1916
Watercolor on paper, 14 x 20 in.
Charles E. Burchfield Collection and DC Moore Gallery, New York

Edwin Dickinson (American, 1891-1978)
Bible Reading Aboard the Tegetthoff, 1926
Oil on cardboard, 19⅞ x 23¹³⁄₁₆ in.
Munson-Williams-Proctor Arts Institute, Museum of Art, Utica, New York

Exhibition Checklist

1. Admiral Richard Brydges Beechey (British, 1808-1895). *HMS* Erebus *passing through the chain of bergs 1842*, n.d. Oil on canvas, 31 x 44 in. National Maritime Museum, London (p. 22)

2. Thomas Birch (American, 1779-1851). *The Ship* Ohio, 1829. Oil on canvas, 20¼ x 30¼ in. © Shelburne Museum, Shelburne, Vermont (p. 96)

3. Eugène Boudin (French, 1824-1898). *A Squall*, 1885. Oil on canvas, 25¹¹⁄₁₆ x 33⅝ in. The Montreal Museum of Fine Arts, Dr. Francis J. Shepherd Bequest (p. 70)

4. Ashley Bowen (American, 1728-1813). *Ship* Postillion, n.d. Watercolor on paper, 11½ x 15 in. Peabody Essex Museum, Salem, Massachusetts (p. 84)

5. William Bradford (American, 1823-1892). *Caught in the Ice Floes*, ca. 1867. Oil on canvas, 27¼ x 44¼ in. © The New Bedford Whaling Museum (p. 35)

6. William Bradford (American, 1823-1892). *Whaler Pinched-In*, n.d. Ink, 4½ x 8 in. © The New Bedford Whaling Museum

7. Charles Burchfield (American, 1893-1967). *Landscape with Rain*, 1917. Watercolor on paper, 13½ x 19½ in. Private Collection courtesy DC Moore Gallery, New York (p. 120)

8. Charles Burchfield (American, 1893-1967). *Lull in Summer Rain*, 1916. Watercolor on paper, 14 x 20 in. Charles E. Burchfield Collection and DC Moore Gallery, New York (p. 121)

9. James Edward Buttersworth (American, 1817-1894). *British Steamer* Gallia *in a Storm*, 1880. Oil on canvas, 23¾ x 35½ in. Peabody Essex Museum, Salem, Massachusetts (p. 99)

10. James Edward Buttersworth (American, 1817-1894). Flying Cloud *Rounding Cape Horn*, n.d. Oil on canvas, 20 x 30 in. Courtesy James C. and Virginia W. Meade (p. 98)

11. George Chambers (British, 1803-1840). *The Crew of HMS* Terror *Saving the Boats and Provisions on the Night of 15ᵗʰ March (1837)*, 1838. Oil on canvas, 23¾ x 33 in. The Beaverbrook Art Gallery, Fredericton, NB, Canada, Purchased with a Minister of Communications Cultural Property Grant and funds from the friends of the Beaverbrook Art Gallery (p. 36)

12. Chinese Artist. *Ship* John Currier, n.d. Oil on canvas, 17¼ x 22¾ in. Peabody Essex Museum, Salem, Massachusetts

13. Thomas Cole (American, 1801-1848). *Gelyna (View Near Fort Ticonderoga)*, 1926-1929. Oil on panel, 24 x 34½ in. Fort Ticonderoga Museum (p. 64)

14. Thomas Cole (American, 1801-1848). *Ruined Tower (Mediterranean Coast Scene with Tower)*, ca. 1832-1836. Oil on composition board, 26¾ x 34 in. Albany Institute of History and Art Purchase (p. 115)

15. Thomas Cole (American, 1801-1848). *Voyage of Life: Old Age*, 1840. Oil on canvas, 25 x 37 in. Collection Neuberger Museum of Art, Purchase College, State University of New York, Gift of Roy R. Neuberger (p. 68)

Editors Note
Throughout this publication, names of ships are given in italics. When included in italicized titles, ship names are alternatively set in Roman type.

16. Michele Felice Cornè (American, ca. 1752-1845). *America of Charleston 8 Days from Grand Bank to the Channel of England, May 1789*, n.d. Gouache on paper, 13 x 18 in. Peabody Essex Museum, Salem, Massachusetts

17. Michele Felice Cornè (American, ca. 1752-1845). *Cap Cook Cast a Way on Cape Cod 1802*, n.d. Gouache on paper, 13½ x 15½ in. Peabody Essex Museum, Salem, Massachusetts (p. 88)

18. Michele Felice Cornè (American, ca. 1752-1845). *Volusia of Salem Cotting the Measan Mast February 22 1802*, n.d. Gouache on paper, 13½ x 15½ in. Peabody Essex Museum, Salem, Massachusetts (p. 89)

19. Gustave Courbet (French, 1819-1877). *Beach at Dieppe*, 1865-1870. Oil on canvas, 24 x 36 in. Collection of the Phoenix Art Museum, Gift of Mr. & Mrs. Arthur Murray (p. 71)

20. Jasper Francis Cropsey (American, 1823-1900). *Passing Shower on the Hudson*, 1885. Oil on canvas, 13¹⁵⁄₁₆ x 25½ in. Davis Museum and Cultural Center, Gift of Mrs. Leeds A. Wheeler (Marion Eddy, Class of 1924) (p. 103)

21. Jasper Francis Cropsey (American, 1823-1900). *The Cove – A Storm Scene in the Catskill Mountains*, 1851. Oil on canvas, 59¹³⁄₁₆ x 47⁷⁄₁₆ in. © The Cleveland Museum of Art, Gift of The Horace Kelley Art Foundation, 1946.494 (p. 100)

22. Eugène Delacroix (French, 1798-1863). *Christ Asleep during the Tempest*, n.d. Oil on canvas, 20 x 24 in. The Metropolitan Museum of Art, H.O. Havemeyer Collection, Bequest of Mrs. H.O. Havemeyer, 1929 (p. 10)

23. Edwin Dickinson (American, 1891-1978). *Bible Reading Aboard the* Tegetthoff, 1926. Oil on cardboard, 19⅞ x 23¹³⁄₁₆ in. Munson-Williams-Proctor Arts Institute, Museum of Art, Utica, New York, 68.36 (p. 122)

24. Clement Drew (American, 1806-1889). *Maine, Boon Island Lighthouse*, n.d. Oil on canvas, 20 x 29½ in. Peabody Essex Museum, Salem, Massachusetts

25. Sanford Robinson Gifford (American, 1823-1880). *Study of a Coming Storm on Lake George*, 1863. Oil on canvas, 12 x 18 in. The Butler Institute of American Art, Youngstown, Ohio, Gift of Almira Wick (p. 79)

26. Jan van Goyen (Dutch, 1596-1656). *The Thunderstorm*, 1641. Oil on canvas, 54¼ x 72⅛ in. Fine Arts Museums of San Francisco, Museum Purchase, M.H. de Young Memorial Museum, 48.7 (p. 30)

27. James Hamilton (American, 1819-1878). Old Ironsides, 1863. Oil on canvas, 60⅜ x 48 in. Courtesy of the Pennsylvania Academy of the Fine Arts, Philadelphia. Gift of Caroline Gibson Taitt (p. 32)

28. Francis Hayman (British, 1708-1776). *King Lear in a Storm*, ca. 1745-1750. Oil on canvas, 14¼ x 23½ in. Oklahoma City Museum of Art, Museum Purchase

29. Robert Henri (American, 1865-1929). *Storm Tide*, 1903. Oil on canvas, 26 x 32 in. Whitney Museum of American Art, New York, Purchase (p. 119)

30. Robert Henri (American, 1865-1929). *Surf and Rocks*, 1911. Oil on board, 11⅞ x 15 in. Memphis Brooks Museum of Art, Memphis, TN; Bequest of Isaac L. Myers 61.221

31. Winslow Homer (American, 1836-1910). *Dad's Coming!* 1873. Electrotype from wood engraving, 11⅜ x 13⅜ in. Des Moines Art Center Permanent Collections, Gift of Richard and Kay Ward

32. Winslow Homer (American, 1836-1910). *Eight Bells*, 1887. Etching in black ink, 23⅞ x 29⅜ in. Brooklyn Museum, Bequest of Anita Steckler (p. 74)

33. Winslow Homer (American, 1836-1910). *On the Bluff at Long Branch, at the Bathing Hour*, 1870. Electrotype from wood engraving, 15⅞ x 10¹⁵⁄₁₆ in. Des Moines Art Center Permanent Collections, Gift of Richard and Kay Ward (p. 117)

34. Winslow Homer (American, 1836-1910). *Perils of the Sea*, 1888. Etching in black ink, 21¹⁄₁₆ x 28 in. Brooklyn Museum, Carl H. de Silver Fund (p. 75)

35. Winslow Homer (American, 1836-1910). *The Life Line*, 1884. Etching in green ink with aquatint and drypoint, 17½ x 23 in. Brooklyn Museum, Carl H. de Silver Fund (p. 108)

36. Winslow Homer (American, 1836-1910). *Winter at Sea – Taking in Sail off the Coast*, 1869. Electrotype from wood engraving, 15¾ x 11⅛ in. Des Moines Art Center Permanent Collections, Gift of Richard and Kay Ward (p. 116)

37. George Inness (American, 1825-1894). *The Coming Storm*, 1878. Oil on canvas, 16 x 24 in. Munson-Williams-Proctor Arts Institute, Museum of Art, Utica, New York, 54.73 (p. 78)

38. Eugène Isabey (French, 1803-1886). *Brittany Coast Scene*, 1860. Oil on canvas, 18.2 x 26 in. The Montreal Museum of Fine Arts, Gift of David A. Wanklyn (p. 6)

39. John F. Kensett (American, 1816-1872). *Passing Off of the Storm*, 1872. Oil on canvas, 11⅜ x 24½ in. The Metropolitan Museum of Art, Gift of Thomas Kensett, 1874 (p. 54)

40. John Linnell (British, 1792-1882). *The Storm*, 1853. Oil on canvas, 35½ x 57½ in. Philadelphia Museum of Art, John Howard McFadden Collection, 1928 (p. 44)

41. Philippe-Jacques de Loutherbourg (French, 1740-1812). *Landscape with Overturned Wagon in a Storm*, 1809. Oil on canvas, 28¼ x 41½ in. Mead Art Museum, Amherst College, Amherst, Massachusetts, Purchased in honor of Susan Dwight Bliss, AC 1974.30 (p. 48)

42. Philippe-Jacques de Loutherbourg (French, 1740-1812). *The Smugglers Return*, 1801. Oil on canvas, 29¼ x 42 in. Joslyn Art Museum, Omaha, Nebraska, Gift of Mr. and Mrs. Arthur Wiesenberger (p. 19)

43. John Marin (American, 1870-1953). *Rough Sea, Cape Split, Maine*, 1932. Oil on canvas, 22 x 28 in. Oklahoma City Museum of Art, Museum Purchase (p. 118)

44. John Martin (British, 1789-1854). *The Deluge*, ca. 1828. Mezzotint on india applique, 26¹³⁄₁₆ x 35⅞ in. Georgia Museum of Art, University of Georgia; University Purchase (p. 13)

45. Samuel Middiman (British, 1750-1831). *Scene from Winter's Tales by William Shakespeare*, 1794. Engraving, 19½ x 25½ in. Oklahoma City Museum of Art, Gift of Mr. and Mrs. Martin Wiesendanger (p. 20)

46. Jan Mooy (Dutch, 1776-1847). *Ship* Janson *Cut Through by Texel River Ice*, n.d. Watercolor on paper, 14¾ x 20¾ in. Peabody Essex Museum, Salem, Massachusetts (p. 97)

47. Edward Moran (American, 1829-1901). *Shipwreck*, 1862. Oil on canvas, 30 x 40 in. Munson-Williams-Proctor Arts Institute, Museum of Art, Utica, New York, 81.13 (p. 63)

48. Thomas S. Moran (American, 1837-1926). *An Angry Sea*, ca. 1897. Oil on canvas, 30¼ x 40⅛ in. The Philbrook Museum of Art, Tulsa, Oklahoma, Gift of Laura A. Clubb (p. 60)

49. Thomas S. Moran (American, 1837-1926). *Camp in the Mountains*, n.d. Oil on panel, 8 x 12 in. Gilcrease Museum Collection, Tulsa, Oklahoma

50. Thomas S. Moran (American, 1837-1926). *Grand Canyon*, 1907. Oil on canvas, 30¼ x 40¼ in. The Philbrook Museum of Art, Tulsa, Oklahoma, Gift of Laura A. Clubb (p. 57)

51. Thomas S. Moran (American, 1837-1926) *Mountain Peaks (Canyon Buttes in the Mist)*, 1892. Oil on board, 13¹³⁄₁₆ x 9¹³⁄₁₆ in. Gilcrease Museum Collection, Tulsa, Oklahoma

52. Thomas S. Moran (American, 1837-1926). *Mountain Valley*, ca. 1865. Oil on canvas, 39¼ x 56¼ in. The Philbrook Museum of Art, Tulsa, Oklahoma, Museum Purchase (p. 56)

53. Thomas S. Moran (American, 1837-1926). *Summer Storm*, 1903. Oil on canvas, 24 x 36 in. The Butler Institute of American Art, Youngstown, Ohio, Gift of Mr. Alexander J. Revnik 1969 (p. 114)

54. Thomas S. Moran (American, 1837-1926). *Sunset at Sea*, 1906. Oil on canvas, 30³⁄₁₆ x 40³⁄₁₆ in. Brooklyn Museum, Gift of the executors of the estate of Colonel Michael Friedsam (p. 61)

55. George Morland (British, 1763-1804). *Shipwreck*, 1793. Oil on canvas, 38⅛ x 57 in. Philadelphia Museum of Art, The William L. Elkins Collection, 1924

56. Pieter Mulier the Elder (Dutch, ca. 1615-1670). *Whaling in Rough Seas*, ca. 1640. Oil on panel, 15 x 23⁵⁄₁₆ in. Private Collection, Baltimore (p. 31)

57. Catherina Peeters (attributed to) (Flemish, 1615-1676). *Ship and Spouting Whale after a Tempest*, 1660-1675. Oil on canvas, 14½ x 21½ in. ©The New Bedford Whaling Museum (p. 43)

58. William Trost Richards (American, 1833-1905). *Lands End, Cornwall*, 1888. Oil on canvas, 62 x 50 in. The Butler Institute of American Art, Youngstown, Ohio, Museum Purchase 1919 (p. 111)

59. Salvator Rosa (Italian, 1615-1673). *The Nurture of Jupiter*, ca. 1659. Oil on canvas, 78¹⁵⁄₁₆ x 52¾ in. Davis Museum and Cultural Center, Gift of Dr. and Mrs. Arthur K. Solomon (p. 46)

60. Robert Salmon (American, ca. 1775-ca. 1851). *Greenock 1818*, n.d. Oil on panel, 11¾ x 15⅛ in. Courtesy Susan W. Meade (p. 38)

61. Dominic Serres (British, 1722-1793). *HMS* Amazon *overset in a gale off the Island of Martiniqua, October 1780*, n.d. Ink and wash on paper, 12 x 17 in. Peabody Essex Museum, Salem, Massachusetts (p. 87)

62. Admiral William Smyth (British, 1800-1877). *Disruption of the Ice Around Her Majesty's Ship* Terror. *Captain Back. July, 1837*, ca. 1837. Watercolor over graphite on paper laid down on paper mount, 6⅞ x 9¹³⁄₁₆ in. The Beaverbrook Art Gallery, Fredericton, NB, Canada, Purchased with a Minister of Communications Cultural Property Grant and funds from the Estate of Mrs. Mae Atkinson Benoit

63. Admiral William Smyth (British, 1800-1877). *His Majesty's Ship* Terror. *Aug 28ᵗʰ 1836 Beset in the Ice Fox Channel*, ca. 1837-1838. Watercolor over graphite on paper laid down on paper mount, 6½ x 9¹¹⁄₁₆ in. The Beaverbrook Art Gallery, Fredericton, NB, Canada, Purchased with a Minister of Communications Cultural Property Grant and funds from the Estate of Mrs. Mae Atkinson Benoit

64. Admiral William Smyth (British, 1800-1877). *Perilous position of HMS* Terror, *Captain Back, in the Arctic Regions in the summer of 1837*, n.d. Oil on canvas, 33 x 48 in. National Maritime Museum, London (p. 37)

65. Clarkson Stanfield (British, 1793-1867). *Shipwreck off a Rocky Coast — Savona*, n.d. Oil on panel, 8³⁄₁₆ x 12⅞ in. The Beaverbrook Art Gallery, Fredericton, NB, Canada, Gift of the Second Beaverbrook Foundation (p. 16)

66. F. Stuart (unknown). *Unidentified Ship, The Night of 7ᵗʰ of September*, n.d. Ink and wash on paper, 8¹¹⁄₁₆ x 12⅞ in. Peabody Essex Museum, Salem, Massachusetts

67. James Jacques Joseph Tissot (French, 1836-1902). *A Passing Storm*, 1876. Oil on canvas, 30¼ x 39¼ in. The Beaverbrook Art Gallery, Fredericton, NB, Canada, Gift of the Sir James Dunn Foundation (p. 25)

68. J.M.W. Turner (British, 1775-1851). *Figures on a Beach*, ca. 1840-1845. Oil on paper, 10³⁄₁₆ x 11¾ in. Tate Gallery, London (p. 50)

69. J.M.W. Turner (British, 1775-1851). *Red Sky over a Beach*, ca. 1840-1845. Oil on paper (unique), 11¹⁵⁄₁₆ x 18⅞ in. Tate Gallery, London (p. 51)

70. J.M.W. Turner (British, 1775-1851). *Ship in a Storm*, ca. 1840-1845. Oil on board, 11⅞ x 18¾ in. Tate Gallery, London (p. 52)

71. J.M.W. Turner (British, 1775-1851). *Shore Scene with Waves and Breakwater*, ca. 1835. Oil on board, 9 x 12 in. Tate Gallery, London (p. 53)

72. Unidentified Artist. *This Shews the Schooner* Baltick *in distress in 6 fathoms of Water on Nantucket Sholes with every thing wash'd of the Deck & Two men Drounded y, 19ᵗʰ of Dec.*, n.d. Watercolor on paper, 13¼ x 18¼ in. Peabody Essex Museum, Salem, Massachusetts (p. 83)

73. Claude-Joseph Vernet (French, 1714-1789). *The Storm*, 1787. Oil on canvas, 45 x 59⅝ in. Wadsworth Atheneum Museum of Art, Hartford, CT. The Ella Gallup Sumner and Mary Catlin Sumner Collection Fund (p. 17)

74. Simon de Vlieger (Dutch, ca. 1601-1653). *A Ship Wrecked off a Rocky Coast*, 1640. Oil on panel, 29½ x 40 in. National Maritime Museum, London. Acquired with the assistance of the National Art Collections Fund (p. 26)

75. Samuel Walters (British, 1811-1882). Houqua, 1848. Oil on canvas, 27¼ x 42¼ in. Peabody Essex Museum, Salem, Massachusetts (p. 80)

76. Samuel Walters (British, 1811-1882). *Ship* Nonantum, 1842. Oil on canvas, 23½ x 35½ in. Peabody Essex Museum, Salem, Massachusetts (p. 92)

77. Samuel Walters (British, 1811-1882). *Steamer* Pacific, ca. 1852. Oil on canvas, 37¼ x 47½ in. Peabody Essex Museum, Salem, Massachusetts (p. 93)

78. Homer Ransford Watson (Canadian, 1855-1936). *A Coming Storm in the Adirondacks*, 1879. Oil on canvas, 33¾ x 46⅝ in. The Montreal Museum of Fine Arts, Gift of George Hague (p. 45)

79. Grant Wood (American, 1892-1942). *Approaching Storm*, 1940. Lithograph on cream wove paper, 12½ x 9½ in. Oklahoma City Museum of Art, Gift of The Winston and Ada Eason Collection of "Monuments of American Graphic Arts," Wave Foundation, Donor

80. William G. Yorke (British, 1817-1888). *Packet Ship Bridgewater*, 1867. Oil on canvas, 24 x 36 in. Courtesy James C. and Virginia W. Meade (p. 86)

Bibliography

Books, Catalogues, and Dissertations

Alphabetical List of Ship Registers, District of Boston, Massachusetts, 1802-1860. Vol. 1. Boston: Works Progress Administration, 1939.

Anderson, Nancy. *Thomas Moran*. New Haven: Yale University Press, 1997.

Arts Council of Great Britain. *Shock of Recognition: The Landscape of English Romanticism and the Dutch Seventeenth-Century School*. London: Arts Council, 1971.

Auden, W. H. *The Enchafèd Flood or the Romantic Iconography of the Sea*. New York: Random House, 1950.

Avery, Emmett L., et. al. *The London Stage 1660-1800*. Part 5: *1776-1800*. 3 vols. Carbondale: South Illinois University Press, 1968.

Ayres, William. *Picturing History: American History 1770-1930*. New York: Rizzoli, 1993.

Balston, Thomas. *John Martin, 1799-1854: His Life and Works*. London: G. Duckworth, 1947.

Baigell, Matthew. *Thomas Cole*. New York: Watson-Guptill Publications, 1981.

Barker, Virgil. *American Painting*. New York: Macmillan, 1950.

Barrell, John. *The Dark Side of the Landscape: The Rural Poor in English Painting, 1730-1840*. Cambridge: Cambridge University Press, 1980.

Beam, Philip C. *Winslow Homer at Prout's Neck*. Boston: Little, Brown and Company, 1966.

Bermingham, Ann. *Landscape and Ideology: the English Rustic Tradition, 1740-1860*. Berkeley: University of California Press, ca. 1986.

Bol, Laurens J. *Die holländische Marinemalerei des 17. Jahrhunderts*. Braunschweig: Klinkhardt & Biermann, 1973.

Bowness, Alan, Marie Thérèse de Forges, and Michel Laclotte. *Gustave Courbet 1819-1877*. London: Arts Council of Great Britain, 1978.

Bowron, Edgar Peters and Mary G. Morton. *Masterworks of European Painting in the Museum of Fine Arts, Houston*. Princeton, New Jersey: Princeton University Press, 2000.

Brewer, John. *The Pleasures of Imagination: English Culture in the Eighteenth Century*. New York: Farrar Straus Giroux, 1997.

Brewington, M.V. and Dorothy. *The Marine Paintings and Drawings in the Peabody Museum*. Salem: The Peabody Museum of Salem, 1981.

Brown, David Blayney. *Augustus Wall Callcott*. London: Tate Gallery, 1981.

—. *Turner in the Alps: 1802*. London: Tate Gallery, 1999.

Butlin, Martin and Evelyn Joll. *The Paintings of J.M.W. Turner*. New Haven: Yale University Press, 1984.

Campbell, Michael J. *John Martin: Visionary Printmaker*. England: Campbell Fine Art in association with York City Art Gallery, 1992.

Cash, Sarah. *Ominous Hush: The Thunderstorm Paintings of Martin Johnson Heade*. Fort Worth: Amon Carter Museum, ca. 1994.

Church, Frederic Edwin. *Frederic E. Church: Under Changing Skies: Oil Sketches and Drawings from the Collection of the Cooper-Hewitt, National Museum of Design, Smithsonian Institution*. Philadelphia: Trustees of the University of Pennsylvania, 1992.

Cikovsky, Nicolai Jr. *George Inness*. New York: H. N. Abrams, Inc., 1993.

Clarke, Michael and Nicholas Penny, eds. *The Arrogant Connoisseur, Richard Payne Knight, 1751-1824*. Manchester: Manchester University Press, 1982.

Cordingly, David. *Ships & Seascapes: An Introduction to Maritime Prints, Drawings and Watercolours*. London: Phillip Wilson Publisher Ltd., 1997.

Conisbee, Philip. *Claude-Joseph Vernet, 1714-1789*. London: The Council, 1976.

Conteau, Georges. *Le Déluge Babylonien: suivi Ishtar aux Enfers la Tour de Babel*. Paris: Payot, 1952.

Cubitt, Geoffrey, ed. *Imagining Nations*. Manchester: Manchester University Press, 1998.

Czestochowski, Joseph S. *John Steuart Curry and Grant Wood: A Portrait of Rural America*. Columbia: University of Missouri Press with the Cedar Rapids Art Association, 1981.

Dallas Museum of Fine Arts & Carol Robbins. *The Romantic Vision in America: Seven Painters*. Dallas: Dallas Museum of Art, 1971.

Davidson, A.S. *Samuel Walters – Marine Artist: Fifty Years of Sea, Sail, & Steam*. Coventry: Jones-Sands Publishing, 1992.

Diderot, Denis. *Salons*. Jean Seznec and Jean Adhémar, eds. 2nd edition. 3 vols. Oxford, 1975-1983.

de Beer, Gerlinde. *Ludolf Backhuysen (1630-1708): Sein Leben und Werk*. Zwolle: Waanders Uitgevers, 2002.

Dorment, Richard. *British Painting in the Philadelphia Museum of Art*. Philadelphia: Philadelphia Museum of Art, 1986.

Dreishpoon, Douglas. *Edwin Dickinson: Dreams and Realities*. New York: Hudson Hills Press, 2002.

Driscoll, John Paul and John K. Howat. *John Frederick Kensett: An American Master*. New York: Worcester Art Museum in association with Norton, 1985.

Duncan, Archibald, Esq. *The Mariner's Chronicle*. Philadelphia: James Humphreys, 1806.

Dunlap, William. *History of the Rise and Progress of the Arts of Design in the Unites States*. Vol. 2. New York: Dover Publications, 1969

Edwards, Philip. *The Story of the Voyage: Sea-Narratives in Eighteenth-Century England*. Cambridge: Cambridge University Press, 1994.

Eitner, Lorenz. *19th Century European Painting: David to Cézanne*. Boulder: Westview Press, 2002.

—. *Géricault's Raft of the Medusa*. London: Phaidon, 1972.

Entick, John. *A New Naval History: Or, Compleat View of the British Marine*. London: R. Manby, 1757.

Favis, Roberta Smith. *Martin Johnson Heade in Florida*. Gainesville: University Press of Florida, 2003.

Feaver, William. *The Art of John Martin*. Oxford: Clarendon Press, 1975.

Finamore, Daniel, ed. *Across the Western Ocean: American Ships by Liverpool Artists*. Salem: Peabody Essex Museum, 1995.

Finberg, A.J. *The Life of J.M.W. Turner, R.A.* Oxford: Clarendon Press, 1961.

Fine, Ruth E. *John Marin*. New York: Abbeville Press, 1990.

Fleming, James Rodger. *Meteorology in America, 1800–1870*. Baltimore: Johns Hopkins University Press, 1990.

Flexner, James Thomas. *The World of Winslow Homer, 1836-1910*. New York: Time Inc., 1969.

Gage, John. *Color in Turner: Poetry and Truth*. New York: Praeger, 1969.

—. *J.M.W. Turner: A Wonderful Range of Mind*. New Haven: Yale University Press, 1987.

Gardner, Albert Ten Eyck. *Winslow Homer, American Artist:His World and His Work*. New York: C.N. Potter, 1961.

General List of Merchant Shipping in All Nations. No. 58. Paris: Bureau Veritas, 1886.

Giltaij, Jeroen, and Jan Kelch. *Praise of Ships and the Sea: the Dutch Marine Painters of the 17ʰ Century*. Rotterdam: Museum Boijmans Van Beuningen, 1996.

Goedde, Lawrence O. *Tempest and Shipwreck in Dutch and Flemish Art: Convention, Rhetoric, and Interpretation*. University Park: Pennsylvania State University Press, 1989.

Goodrich, Lloyd. *The Graphic Art of Winslow Homer*. New York: Museum of Graphic Art, 1968.

Greenacre, Francis. *Francis Danby 1793-1861*. London: The Tate Gallery, 1988.

Groseclose, Barbara S. *Emanuel Leutze, 1816-1868: Freedom is the Only King*. Washington D. C.: Smithsonian Institution Press, 1975.

Haak, B. *The Golden Age: Dutch Painters of the Seventeenth Century*. New York: H.N. Abrams Inc., 1984.

Hamilton, James. *Turner: The Late Seascapes*. New Haven: Yale University Press, 2003.

Hartshorne, Richard and John F. H. King. *American Lloyd's Register of American and Foreign Shipping*. New York: R.C. Root, Anthony & Co., 1857.

Hemming, Charles. *British Painters of the Coast and Sea: A History and Gazetteer*. London: V. Gollancz, 1988.

Hendricks, Gordon. *The Life and Works of Winslow Homer*. New York: H. N. Abrams Inc., 1979.

Heninger, S. K. *The Cosmographical Glass*. San Marino, California: Huntington Library, 1977.

Hollander, John, ed. *American Poetry: The Nineteenth Century*. New York: Library of America, 1993.

Home, Henry and Lord Kame. *Elements of Criticism*, vol. 1. 8th edn. Edinburgh and London, 1807.

Huntress, Keith. *A Checklist of Narrative of Shipwrecks and Disasters at Sea to 1860*. Ames: Iowa State University Press, 1979.

Jobert, Barthélémy. *Delacroix*. Princeton: Princeton University Press, 1998.

Johns, Elizabeth, et al. *New Worlds from Old: 19th Century Australian & American Landscapes*. Hartford: Wadsworth Atheneum, 1998.

Johnstone, Christopher. *John Martin*. London: Academy Editions, 1974.

Joppien, Rudiger. *Philippe-Jacques de Loutherbourg, R.A., 1740-1812*. London: Greater London Council, 1973.

Junker, Patricia. *John Steuart Curry: Inventing the Middle West*. New York: Hudson Hills Press, 1998.

Kelly, Franklin. *American Paintings of the Nineteenth Century*. New York: Oxford University Press, 1996-1998.

—. *Frederic Edwin Church and the National Landscape*. Washington, D.C.: Smithsonian Institution Press, 1988.

— and Gerald L. Carr. *The Early Landscapes Frederic Edwin Church, 1845-1854*. Fort Worth: Amon Carter Museum, 1987.

Keyes, George S. *Mirror of Empire: Dutch Marine Art of the Seventeenth Century*. New York: Cambridge University Press, 1990.

Knight, Richard Payne. *Analytical Inquiry into the Principles of Taste*. London: T. Payne, 1808.

Kornhauser, Elizabeth Mankin. *Marsden Hartley*. New Haven: Yale University Press, 2002.

Kriz, Kay Dian. *The Idea of the English Landscape Painter: Genius as Alibi in the Early Nineteenth Century*. New Haven: Yale University Press, 1997.

Kurth, Dr. Willi. *The Complete Woodcuts of Albrecht Dürer*. New York: Dover Publications, Inc., 1963.

Landow, George P. *Images of Crisis: Literary Iconology, 1750 to the Present*. Boston: Routledge & Kegan Paul, 1982.

Lindsay, Jack. *Gustave Courbet: His Life and Art*. London: Bath, Adams & Dart, 1973.

Lochnan, Katharine Jordan. *Turner, Whistler, Monet: Impressionist Visions*. Toronto: Art Gallery of Ontario in association with Tate Pub., 2004.

Locke, John. *An Essay Concerning Human Understanding*. London: Printed by Eliz. Holt for Thomas Bassett, 1689.

Lynam, E., ed. *Richard Hakluyt and his Successors*. London: Hakluyt Society, 1946.

Mack, Gerstle. *Gustave Courbet*. New York: Knopf, 1951.

MacLaren, Neil. *The Dutch School: 1600-1900*. London: National Gallery Publications Ltd., 1991.

Matyjaszkiewicz, Krystyna. *James Tissot*. New York: Abbeville Press, 1984.

Melville, Herman. *Moby-Dick*. New York: Harper & Brothers; London: Richard Bentley, 1851.

Merritt, Howard S. *Thomas Cole*. Rochester, New York: Rochester Lithographics, 1969.

Miller, Angela. *The Empire of the Eye: Landscape Representation and American Cultural Politics, 1825-1875*. Ithaca: Cornell University Press, 1993.

Monk, Samuel H. *The Sublime: A Study of Critical Theories in XVIII-century England*. New York: Modern Language Association of America, 1935.

Morford, Mark P.O. *The Poet Lucan: Studies in Rhetorical Epic*. Oxford: Blackwell, 1967.

Morris, Harrison S. *Masterpieces of the Sea: William T. Richards, a Brief Outline of his Life and Art*. Philadelphia and London: J.B. Lippincott, 1912.

Muller, Nancy C. *Paintings and Drawings at the Shelburne Museum*. Vermont: Lane Press, 1976.

Neill, Peter. *On a Painted Ocean: Art of the Seven Seas*. New York: New York University Press, 1996.

Nicolson, Marjorie Hope. *The Breaking of the Circle*, rev. ed. New York: Columbia University Press, 1962.

Novak, Barbara. *American Painting of the Nineteenth Century; Realism, Idealism, and the American Experience*. New York: Praeger, 1969.

—. *Nature and Culture: American Landscape Painting, 1825-1875*, rev. ed. New York: Oxford University Press, 1995.

Palley, Reese and Marilyn Arnold Palley. *Wooden Ships and Iron Men: The Maritime Art of Thomas Hoyne*. New York: Quantuck Lane Press, 2005.

Parry III, Ellwood C. *The Art of Thomas Cole, Ambition and Imagination*. Newark: University of Delaware Press, 1988.

Perlman, Bennard B. *The Immortal Eight: American Painting from Eakins to the Armory Show*. Westport, Connecticut: North Light Publishers, 1979.

Powell III, Earl A. *The National Gallery of Art, Washington*. New York: Thames and Hudson, 1992.

—. *Thomas Cole*. New York: H.N. Abrams, 1990.

Quick, Michael. *George Inness*. New York: Harper and Row Publisher's, Inc., 1985.

Ranlett, Frederick Jordan. *Daily Journal, September 26, 1874*. Manuscript property of John Ranlett.

Raven, James. *Judging New Wealth: Popular Publishing and Responses to Commerce in England, 1750-1800*. Oxford: Clarendon Press, 1992.

Record of American and Foreign Shipping. New York: American Shipmaster's Association, 1891.

Robertson, Bruce. *Reckoning with Winslow Homer: His Late Paintings and Their Influence*. Cleveland, Ohio: Cleveland Museum of Art, 1990.

Rosenblum, Robert. *19th Century Art*. New York: H.N. Abrams, 1984.

—. *Transformations in Late Eighteenth Century Art*. Princeton: Princeton University Press, 1967.

Russett, Alan. *Dominic Serres R.A. 1719-1793: War Artist to the Navy*. Wappinger's Falls, New York: Antique Collectors' Club, 2001.

Saur, K.G. *Allgemeines Künstlerlexikon: die bildenden Künstler aller Zeiten und Völker*. München: Saur, 1994.

Schweizer, Paul D., ed. *Masterworks of American Art from the Munson-Williams-Proctor Institute*. New York: H. N. Abrams, 1989.

Sérullaz, Arlette. *Delacroix: The Late Work*. New York: Thames & Hudson, 1998.

Shanes, Eric. *Turner's Human Landscape*. London: Heinemann, 1990.

Shazo, Edith. *Everett Shinn: 1873-1953*. Trenton: New Jersey State Museum, 1973.

Slive, Seymour. *Dutch Painting 1600-1800*. New Haven: Yale University Press, 1995.

—. *Jacob van Ruisdael*. New York: Abbeville Press, 1982.

Sloan, Kim. *Alexander and John Robert Cozens: The Poetry of Landscape*. New Haven: Yale University Press, 1986.

Smith, Phillip Chadwick Foster, ed. *The Journals of Ashley Bowen (1728-1813) of Marblehead*. Boston: The Colonial Society of Massachusetts, 1973.

Smith, Rev. G.C. *The Wreckers; or, a Tour of Benevolence from St. Michael's Mount to the Lizard Point Interspersed with Descriptive Scenery of Mount's Bay, Cornwall*. London: W. Whittemore, 1818.

Solkin, David H. *Painting for Money: The Visual Arts and the Public Sphere in the Eighteenth-Century*. New Haven: Yale University Press, 1993.

Stebbins Jr., Theodore E. *The Life and Works of Martin Johnson Heade*. New Haven: Yale University Press, 1975.

Stein, Roger B. *Seascape and the American Imagination*. New York: C. N. Potter, 1975.

Strauss, Walter L., ed. *Netherlandish Artists: Matham, Saenredam, Muller*. New York: Abaris Books, 1980.

Suderland, John. *Constable*. London: Phaidon, 1971.

Sutton, Peter C. *Northern European Paintings in the Philadelphia Museum of Art*. Philadelphia: The Philadelphia Museum of Art, 1990.

Sweet, Frederick A. *The Hudson River School and the Early American Landscape Tradition*. New York: Whitney Museum of American Art, 1945.

Taylor, Basil. *Constable: Paintings, Drawings and Watercolors*. London: Phaidon, 1975.

Tatham, David. *Winslow Homer and the Illustrated Book*. Syracuse: Syracuse University Press, 1992.

Thoreau, Henry David. *Walden*. Boston: Houghton Mifflin, 1995.

Thornbury, Walter. *Life of J.M.W. Turner, R.A.* London: Hurst & Blackett, 1862.

Tippetts, Marie-Antoinette. *Les Marines des peintres vues par les littérateurs de Diderot aux Goncourts*. Paris: A.G. Nizet, 1966.

Truettner, William H. and Alan Wallach. *Thomas Cole: Landscape into History*. New Haven: Yale University Press, 1994.

Turner, J.M.W. *J.M.W. Turner: Galeries nationales du Grande Palais, Paris, 14 Octobre 1983-16 janvier 1984: à l'occasion du cinquantième anniversaire du British Council*. Paris: Ministère de la culture, Editions de la Réunion des musées nationaux, ca. 1983.

van de Waal, H. *Drie eeuwen vaderlandsche geschieduitbeelding, 1500-1800*. 2 vol. The Hague, 1952.

Vaughn, William. *Romanticism and Art*. London: Thames and Hudson, 1994.

Walford, E. John. *Jacob van Ruisdael and the Perception of Landscape*. New Haven: Yale University Press, 1991.

Warburg, Aby M. *Images from the Region of the Pueblo Indians of North America*. Translated by Michael P. Steinberg. Ithaca: Cornell University Press, 1995.

Ward, John L. *Edwin Dickinson: A Critical History of His Paintings*. Newark: University of Delaware Press, 2003.

Warrell, Ian, ed. *Turner and Venice*. New York: H. N. Abrams, 2003.

—. *Turner, the Fourth Decade: Watercolors 1820-1830*. London: Tate Gallery, 1991.

Werner, Alfred. *Inness Landscapes*. New York: Watson-Guptill, 1973.

Wilkins, Thurman with the help of Caroline Lawson Hinkley. *Thomas Moran: Artist of the Mountains*. Foreword by William H. Goetzmann. Norman: University of Oklahoma Press, 1998.

Wilmerding, John. *American Light, The Luminist Movement, 1850-1875: Paintings, Drawings and Photographs*. Washington, D.C.: Harper & Row, 1980.

—. *American Marine Painting*. New York: H. N. Abrams, 1987.

—. *The Artist's Mount Desert: American Painters of the Maine Coast*. Princeton: Princeton University Press, 1994.

—. *Winslow Homer*. New York: Praeger Publishers, 1972.

Wilton, Andrew and Tim Barringer. *American Sublime Landscape Painting in the United States 1820-1880*. Princeton: Princeton University Press, 2002.

—. *Turner and the Sublime*. Chicago: University of Chicago Press, 1981.

—. *Turner and the Sublime*. London: British Museum Publications, 1980.

Wood, Christopher. *Tissot: The Life and Works of Jacques Joseph Tissot 1836-1902*. London: Weidenfeld and Nicholson, 1986.

Wood, Peter H. *Weathering the Storm*. Athens: The University of Georgia Press, 2004.

Articles in Periodicals and Anthologies

Addison, Joseph. *The Spectator* (June and July 1712).

Alloway, Lawrence. "The Recovery of Regionalism: John Steuart Curry." *Art in America*, vol. 64 (July, 1976): 70-3.

Berlind, Robert. "Edwin Dickinson: Waking Visions." *Art in America* (February 2003).

Billias, George Athan. "The Journals of Ashley Bowan (1728-1813) of Marblehead." *The New England Quarterly*, vol. 47, no. 1 (March 1974): 14-143.

Boase, T.S.R. "Shipwrecks in English Romantic Painting." *Journal of the Warburg and Courtauld Institutes*, vol. 22 (1959): 332-346.

Bonehill, John. "Hodges's Post-voyage Work." *William Hodges 1744-1797: The Art of Exploration*. New Haven: Yale Center for British Art, 2004.

Bradford, William. "New Discoveries." *The American Art Journal* (Winter, 1983): 91-2.

Breidenbach, Tom. "Edwin Dickinson: Tibor de Nagy Gallery." *ArtForum* (December, 2002).

Butlin, Martin. "Toronto, New Haven and London. Turner and the Sublime." *The Burlington Magazine*, vol. 123, no. 938 (May, 1981): 319-20.

Clarke, James Stanier. *Naufragia or Historical Memoirs of Shipwrecks and the Providential Deliverance of Vessels by James Stanier Clarke F.R.S. Chaplain of the Prince's Household and Librarian to His Royal Highness*, vol. 2 (London, 1805-6): vii.

Conisbee, Philip. "Claude Vernet: Munich." *The Burlington Magazine*, vol. 139, no. 1133 (August, 1997): 567-8.

—. "Salvator Rosa and Claude Vernet." *The Burlington Magazine*, vol. 115, no. 849 (December, 1973): 789-94.

Cropsey, Jasper F. "The Brushes he painted with that last day are there: Jasper F. Cropsey's letter to his wife, describing Thomas Cole's home and studio, July, 1850." *American Art Journal*, vol. 16, no. 3 (Summer, 1984): 78-83.

—. "Up among the Clouds:" *Crayon* 2 (8 August 1855): 79.

Cyriax, Richard J. "Sir John Franklin's last Arctic expedition: a chapter in the history of the royal navy." *Arctic* (December, 1997).

Driscoll, John P. "William Trost Richards' 'The Forest' Rediscovered." *American Art Journal*, vol. 10, no. 2 (November, 1978): 106-7.

Eager, Gerald. "The Iconography of the Boat in the 19th Century American Painting." *Art Journal*, vol. 35, no. 3 (Spring, 1976): 224-30.

Eitner, Lorenz. "The Open Window and the Storm-Tossed Boat: An Essay in the Iconography of Romanticism." *The Art Bulletin*, vol. 37, no. 4 (December, 1955): 281-90.

Falconer, John. "'Thomas Cole is No More': A Letter from John Falconer to Jasper Cropsey February 24, 1848." *American Art Journal*, vol. 15, no. 4 (Autumn, 1983): 74-7.

Ferber, Linda S. "John Brown's Grave and other themes in William T. Richard's Adirondack landscapes." *Magazine Antiques* (July, 2002).

Finamore, Daniel. "The Unknowable Sea: Maritime Paintings at Mystic." *America and the Sea: Treasures from the Collections of Mystic Seaport*. New Haven: Yale University Press, 2005.

Frey, Gerhard. "Elemente." *Reallexikon zur deutschen Kunstgeschichte*, vol. 4, (1937): 1256-1261.

Gedzelman, Stanley David. "Weather Forecasts in Art." *Leonardo*, vol. 24, no. 4. Great Britain: Pergamon Press, 1991: 441-51

George, Hardy. "Turner in Venice." *The Art Bulletin*, vol. 53, no. 1 (March, 1971): 84-7.

Gerdts, William H. "American Landscape Painting: Critical Judgements, 1730-1845." *The American Art Journal* (Winter, 1985).

Goedde, Lawrence O. "Convention, Realism, and the Interpretation of Dutch and Flemish Tempest Painting." *Simiolus*, vol. 16, no. 2/3, (1986): 139-49.

Graff, Vincent. "A New Perspective." *The Independent (London)* (23 September 2003).

Greben, Deidre Stein. "Everett Shinn." *Art News*, vol. 96 (April 1997): 133.

Griffin, Randall C. "The Untrammeled Vision: Thomas Cole and the Dream of the Artist." *Art Journal*, vol. 52, no. 2, Romanticism (Summer, 1993): 66-73.

Grimes, Nancy. "Edwin Dickinson at Tibor de Nagy and Babcock." *Art in America* (March, 1997).

Howard, Kathleen. "Jacob Van Ruisdael." *The Metropolitan Museum of Art Guide*. New York: The Metropolitan Museum of Art, 1983.

Howat, John K. "The Hudson River School." *The Metropolitan Museum of Art Bulletin*, vol. 30, no. 6 (June-July, 1972): 272-83.

"Jacob van Ruisdael." *National Gallery, Washington*. New York: Newsweek/Great Museums of the World, 1968.

Johnson, Lee. "Delacroix's 'Christ at the Column.'" *The Burlington Magazine*, vol. 121, no. 920 (November, 1979): 681-85.

Joll, Evelyn. "Turner in Scotland." *The Burlington Magazine*, vol. 124, no. 957 (December, 1982): 786-8.

Kasson, Joy S. "The Voyage of Life: Thomas Cole and Romantic Disillusionment." *American Quarterly*, vol. 27, no. 1 (March, 1975): 42-56.

Ledes, Allison Eckardt. "American Art in New York City." *Magazine Antiques* (November, 2000).

Levitine, George. "Vernet Tied to a Mast in a Storm: The Evolution of an Episode of Art Historical Romantic Folklore." *The Art Bulletin*, vol. 49, no. 2 (1967): 93-100.

Melancholly (sic). *The Register*. Salem, Massachusetts, Monday, 8 March 1802.

Pardee, Hearne. "Selections and Transformations: The Art of John Marin." (The National Gallery of Art/ Kennedy) *Art News*, vol. 89 (Summer, 1990).

Porter, Laurence M. "Space as Metaphor in Delacroix." *The Journal of Aesthetics and Art Criticism*, vol. 42, no. 1 (Autumn, 1983): 29-37.

Quilley, Geoffrey. "William Hodges, Artist of Empire." *William Hodges 1744-1797: The Art of Exploration*. New Haven: Yale Center for British Art, 2004.

Reich, Sheldon. "John Marin: Paintings of New York, 1912." *The American Art Journal*, vol. 1, no. 1 (Spring, 1969): 43-52.

Rexer, Lyle. "Edwin Dickinson at Tibor de Nagy." *Art in America* (February, 2003).

Rule, J. G. "Wrecking and Coastal Plunder." Douglas Hay, Peter Linebaugh and E.P. Thompson, eds. *Albion's Fatal Tree: Crime and Society in Eighteenth-Century England*. London: Allen Lane 1976.

"Ship, Sea and Sky: The Marine Art of James Butterworth." *Museum News* (May-June 1994): 18.

Updike, John. "Ominous Hush: The Thunderstorm of Martin Johnson Heade." *The New York Review of Books* (12 January 1995): 8-10.

Waldman, Diane. "Dickinson: Reality of Reflection." *Art News*, vol. 64 (November, 1965): 28-31.

Vickers, Daniel. "An Honest Tar: Ashley Bowen of Marblehead." *The New England Quarterly*, vol. 69, no. 4 (December, 1996): 531-53.

Venning, Barry. "A Macabre Connoisseurship: Turner, Byron and the Apprehension of Shipwreck Subjects in Early Nineteenth-Century England." *Art History* 8/3 (1985): 303-19.

Yount, Sylvia. "Consuming Drama: Everett Shinn and the Spectacular City." *American Art*, vol. 6, no. 4 (Autumn, 1992): 86-109.

This publication was designed using Adobe Indesign CS2; v. 4.0.2. It was printed in an edition of 1500 using 100 pound Gusto gloss as the text paper and 120 pound Centura (with a satin lamenant) for the cover stock.

The text of this publication was set in Fournier regular, italic, and small caps at 11/18. Fournier was cut by Monotype, Corp. in 1924 and is based on the original design by Pierre Simon Fournie in 1742. Headlines are set in ITC New Baskerville, 24/36. Baskerville was originally designed by John Baskerville in 1752 and recut by George Jones in 1930. Both typefaces are Adobe type one fonts.